MICROSTOCK
MONEY
SHOTS

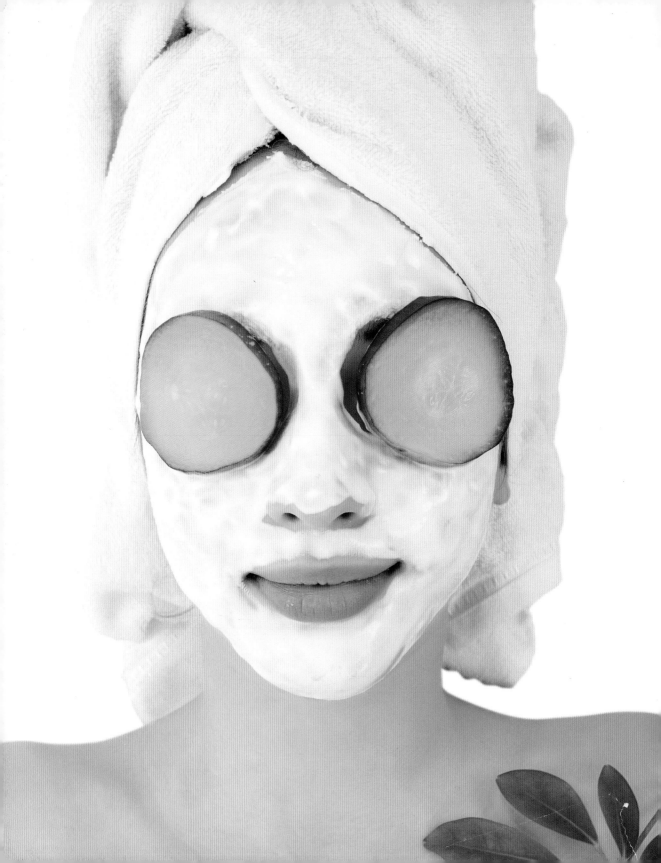

MICROSTOCK MONEY SHOTS

Turning Downloads into Dollars with Microstock Photography

ELLEN BOUGHN

Foreword by Andres Rodriguez

AMPHOTO BOOKS

AN IMPRINT OF THE CROWN PUBLISHING GROUP • NEW YORK

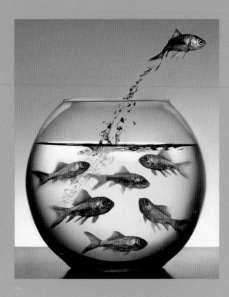

Published in the United States by Amphoto Books,
an imprint of the Crown Publishing Group,
a division of Random House, Inc., New York.
www.crownpublishing.com
www.amphotobooks.com

AMPHOTO BOOKS and the Amphoto Books logo
are registered trademarks of Random House, Inc.

Library of Congress Cataloging-in-Publication Data
Boughn, Ellen.
 Microstock money shots : turning downloads into dollars
with microstock photography / by Ellen Boughn ; foreword
by Andres Rodriguez. — 1st ed.
 p. cm.
 Includes index.
 ISBN 978-0-8174-2497-8 (pbk. : alk. paper)
 1. Stock photography. 2. Internet commerce. 3. Picture
archiving and communication systems. I. Title.
 TR690.6.B68 2010
 770.285'4678—dc22
 2010002543

Printed in China
Design by Debbie Glasserman
10 9 8 7 6 5 4 3 2 1
First Edition

FOR EDDIE AND MAXX

Thanks go to Bob Kirschenbaum and Suzanne Goldstein, from whom I learned so much, and to Nancy Johnson for her lifelong support and friendship. A special acknowledgment is due to Serban Enache and Yuri Arcurs for educating me in the ways of microstock, and a super-huge thank-you to Lee Torrens for his advice, knowledge, and generous assistance in reading an early version of the manuscript. Andres Rodriguez is one of the busiest of microstock photographers, and I am very grateful to him for taking the time to provide his excellent foreword.

THERE ARE NO WORDS LARGE ENOUGH TO DESCRIBE WHAT I OWE TO MY HUSBAND, ED SMITH.

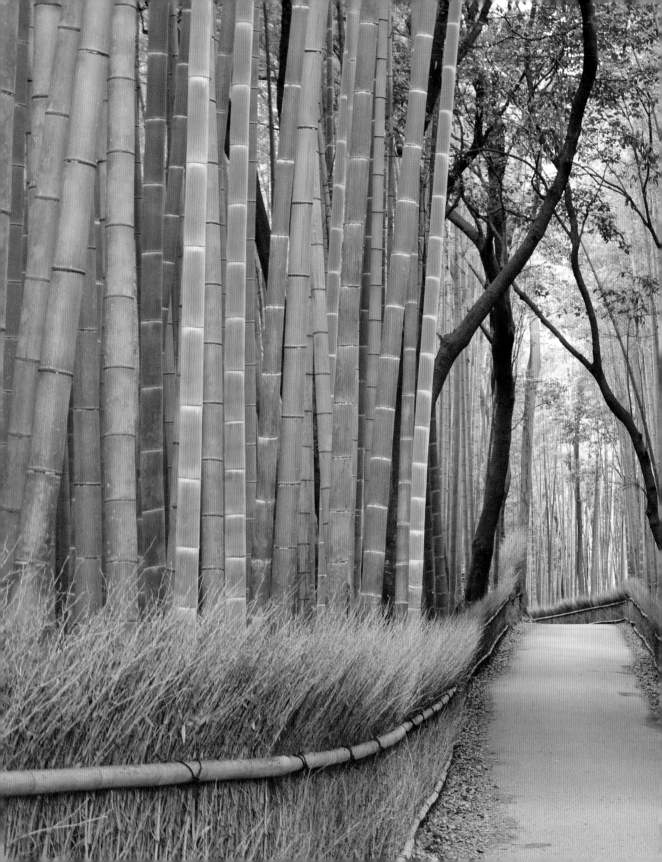

CONTENTS

FOREWORD

BY ANDRES RODRIGUEZ

Microstock is an exciting industry. It's constantly changing as new trends, services, and agencies arrive on the scene. You never know what will happen next and how it will change or affect the business. Microstock is also an industry of opportunity. For most people, getting started is not too difficult: The potential is high for anyone who thinks carefully about the opportunities and works hard to take advantage of them.

I started with microstock in 2004, when the industry was still very young. As a designer, I was buying photos to use on websites and in brochures for my company at the time. It wasn't long, however, before I started noticing how often each photo sold through the microstock agencies, which showed the number of downloads for each image. This is what first made me curious about the field.

For one design project, I needed a photo of a person designing a database structure. I wanted to see the person's face, so I imagined a photo in which the person appeared to be drawing the design on the screen. I searched all the top microstock agencies but could not find anything with this concept (at that time, the agency portfolios were much smaller than they are now). So I created the photo myself, and after using it in my design, uploaded it to some of the biggest microstock agencies. I was surprised at how often the photo sold. Clearly I was not the only person with a need for that particular subject matter. At the time I owned only a point-and-shoot camera and didn't know much about photography, so I wasn't too serious about pursuing more uploads just yet.

Eventually my job situation changed and I needed another way to earn a living. I had heard about a few people who were already "professional" microstock photographers, so I became inspired to try to make micro-stock photography my full-time job as well.

I purchased a book about photography fundamentals and bought my first digital SLR camera. Because I worked so hard to learn and practice as much as I could, I became frustrated after so many of my photos were initially rejected by microstock agencies. Digital noise was my first problem: Microstock agencies will reject images with even the smallest amount of noise, so I had to read about it and understand how to shoot photos that were totally noise-free. Then came problems with focus: If a photo is even slightly blurry, or the focus is not on the logical part of the photo, it will be rejected. Most of my photos were of people, so I had to practice getting the focus perfectly sharp and centered on the eyes of the model. It took a long time to figure out all the elements that agencies wanted and didn't want in a photo. Each time a photo was rejected, I paid attention to the reasons and adjusted my technique accordingly.

After a couple of months, I had gained a good understanding of how to make photos that agencies would accept. The next step was to figure out what made a photo a high seller. I started obsessing over sales stats and looking for common elements among my best-selling photos. I tried different lighting techniques, a variety of models, and a range of styles, from highly conceptual photos to simple shots. It took a couple of months, but I eventually found the combinations that worked best for sales—specifically, flat lighting, realistic but attractive models, and a clear message or concept. This knowledge was the key to reaching high sales. Now that I knew how to create high-selling photos, I could just increase the quantity to raise my earnings. I turned myself into a microstock shooting machine, shooting and uploading as many photos as I could as fast as I could.

After just a few months, I was earning as much as I had earned at my design job (though with all the hard work, it felt a lot longer than a few months!). The hard work was paying off, my earnings were rising quickly, and I continued to constantly improve the quality of my photos.

These days microstock is a different world. New microstock photographers need to start with much better photos than I did, but they also have a big advantage. They don't need to spend months figuring out how to create photos that microstock agencies will accept, nor must they spend months figuring out what kinds of photos sell well—they have it all laid out here, in Ellen's book.

That is not to say that it will be easy. This book will help you avoid many of the frustrations of figuring out what works in microstock, but you still have to put in the effort and invest the time to build a solid portfolio. Your success will equal the effort you put in. Just be sure to use this book to learn how to create high-selling photos *before* you run out and shoot too many: Your motto should be: Quality first, quantity second.

Like so many in the microstock industry, I have known Ellen for some years now. She has great experience in the stock photo industry and is an established authority on microstock. She's the ideal person to write this book, and I'm thrilled to finally be able to refer people to a comprehensive and high-quality guide to microstock photography.

INTRO

At least once a month during my years in the stock photography business I was told that I had to see my neighbor's or my dentist's or a perfect stranger's photos. The remark was usually followed by a description of the work that went something like this: "She isn't a professional, but her photos of flowers and landscapes are wonderful." I would then have to slip out of the conversation because I dreaded what would come next: "Would you like to see the images?"

The fact is, this was the only way most amateur photographers could get their work viewed by someone in stock photography. Then, as now, most traditional stock companies close their doors to amateurs unless their work is specialized and unique. And it's hard to blame them; although most serious amateurs do have some terrific photos, the time required to find the gems among the vacation photos is not cost-efficient for a high-volume traditional stock business.

With the advent of "microstock," the doors have begun to open. What exactly is microstock photography? It's an increasingly lucrative business that has evolved as an offshoot of traditional stock photography, in which fees are charged to license imagery, except the fees to license microstock images are much lower—anywhere from $0.20 to $10.00 for a royalty-free photo. Microstock companies source their images almost exclusively via the Internet and work with a wider range of photographers than the traditional stock agencies, including amateurs and hobbyists. The term *microstock* likely stems from the term *micropayment*, because the licensing fees are radically smaller than those for traditional photography. There is also a strong element of social networking involved in the microstock communities, as contributors communicate freely with each other, offering advice and criticism that is mostly absent among contributors to traditional stock companies. With the microstock platform, amateurs and pros alike have a means to showcase and make money from their images, as long as the images adhere to certain technical rules. Photo editors for microstock companies, called "reviewers," are not nearly as demanding

with respect to subject matter as photo editors at the large stock companies. However, they will still reject certain subjects and, as the number of submissions soars and competition for downloads increases, they are getting more selective.

The microstock licensing model has provided an exciting venue for serious amateur photographers. Instead of letting your photos languish on a hard drive, only to be tossed out decades later, you can submit them to a business—and maybe even make some money. In the process, you'll learn from your mistakes, and your photography and rate of success will improve. The learning experience is practically instantaneous: instead of having to wait weeks or months for new images to be uploaded (as was the case with the traditional stock businesses), microstock images are posted online within a few days. Almost immediately you can begin to learn what sells best (especially if you have followed the advice in this book). Checking to see what has sold in the last day or hour becomes addictive as royalties start to grow.

Before you venture too far down the path of social networking sites as a venue for your photography, however, consider why you want to put your images out into the world. If you enjoy sharing photos with friends and family and are happy with snapshots that tell a story without a lot of fuss on your part, microstock may not be for you. You will probably gain more satisfaction from the less specialized social networks such as Flickr and Facebook as venues for sharing your images. Concern about getting just the right shot could cause you to spend all your leisure time looking at the camera or cell phone rather than enjoying yourself. However, if you are a serious amateur who appreciates getting comments on your work from others and wants to polish your skills to get maximum downloads and even make some money, why not jump on the microstock bandwagon? Even successful stock photographers have found that microstock can add revenue to their income. If you fall into this category, consider this book a compilation of shooting ideas similar to what you would get from an editor at a traditional stock distributor, but modified for microstock.

The growth of the microstock business is nothing short of phenomenal. Expansion has been fueled by the wide availability of relatively inexpensive and higher-resolution digital cameras, the explosion of Internet sites and blogs requiring inexpensive images, and the expansion of photo users gaining expertise about image searches and licensing. For example, when I first joined Dreamstime, a large microstock company, in early 2007, the company had 1,015,806 images, 279,880 users, and 12,857 photographers and illustrators. By fall of 2009, the company could boast of 6,758,821 images, 1,704,726 users, and 78,072 photographers and illustrators. Meanwhile, the quality of the images has improved as microstock photographers have gained experience in what sells and why.

The microstock industry is by no means mature. Almost unlimited opportunities remain as its growth tracks that of businesses and individuals using images on the Web for promotion and information. It is far from being too late to get on board; and with the information you'll find here, you can jump-start your success in the world of microstock photography.

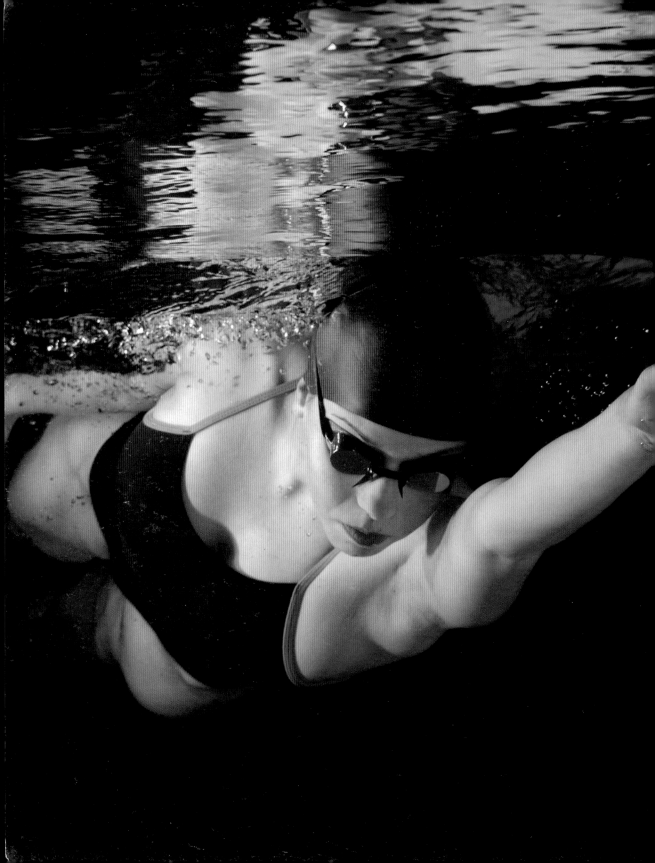

01

WHAT IS MICROSTOCK?
A SNAPSHOT OF THE INDUSTRY

Microstock photography companies such as iStockphoto.com, Dreamstime.com, and Shutterstock.com have allowed professional and amateur photographers alike the opportunity to reach a huge audience for their images and to license the photos for a fee. Before microstock, there was a long line of companies, including Corbis, Getty Images, and Masterfile, that built businesses around licensing professional photographers' stock photos; but for the amateur, few repositories existed for their processed film other than a box in the back of the closet or as sometimes sleep-inducing slideshows for hapless friends and neighbors. Over time, the professional businesses have evolved from offering only editorial-type images to encyclopedias and textbooks or news and publicity file photos to the three major stock photo licensing models that exist today.

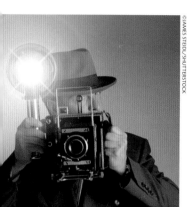

©JAMES STEIDL/SHUTTERSTOCK

This re-creation looks like a typical stock photo depicting a scene from the last century.

❚ A BRIEF HISTORY

In the past, newspaper companies stored their photo archives in the "morgue" (a reference to the thousands of prints and negatives that slowly decayed into dust) until the day they might be needed for publication. Such was the model for the stock photography business, which began in the 1920s as a way to provide similar resources for encyclopedia, calendar, greeting card, and book publishers. The photographers would place their images in a stock agency's files for distribution while still retaining the copyright to the photos. The agency would then license a chosen image to a publisher, take a commission on the transaction, and pay the photographer a royalty.

In the mid-1970s, stock photo agencies expanded to serve the advertising, design, and corporate industries. One of the major advantages for art directors, art buyers, and photo editors was the predictability of stock images: What they saw was what they got—which is not always the case with assignment photography.

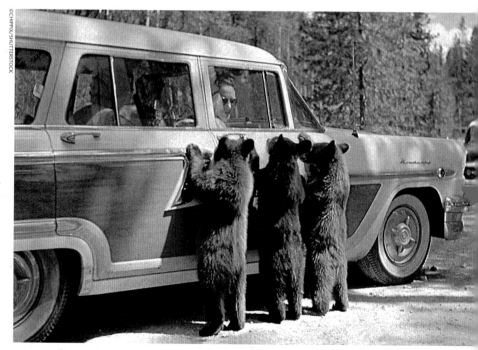

©CHIPPIX/SHUTTERSTOCK

Early stock photo collections were made up of images such as this one from Yellowstone Park in the 1950s. Other popular images included staged family and office scenes.

Over time, the early stock agencies such as H. Armstong Roberts, The Bettmann Archive, and Photo Researchers were joined by companies such as The Image Bank, which geared their collections more to graphic designers and advertising art directors. In the late 1980s, still another player joined the stock photography market. Microsoft founder Bill Gates had begun construction of a new home featuring the best and latest technology, including digital displays for art and photographs. In need of imagery, he started a company called Interactive Home Systems, later renamed Corbis, to secure the digital rights to art and photography. As the collection grew, Corbis began licensing its images.

British company Tony Stone Images (TSI) entered the U.S. market for advertising stock photography in the early 1990s when it purchased After-Image, a company started in Los Angeles in the mid 1970s. In this business model, the stock agency would work closely with established advertising photographers and front all the costs for a photo shoot to

For many years, American textbook and encyclopedia publishers depended on a few photographers to supply images of indigenous people from around the world. Today, thanks to hundreds of thousands of citizen photographers across the globe, such images are easily available on microstock companies' sites.

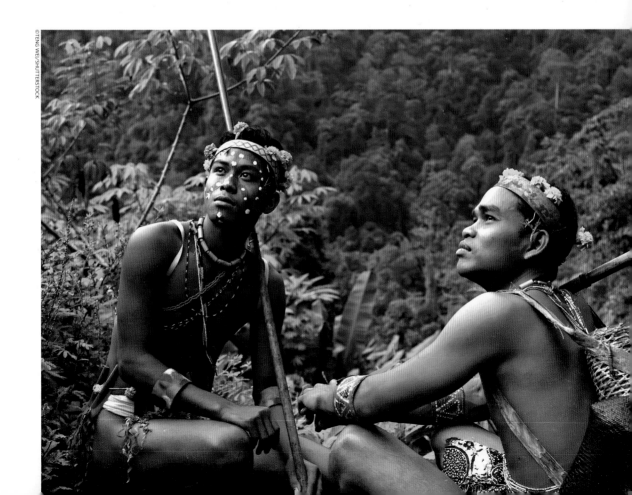

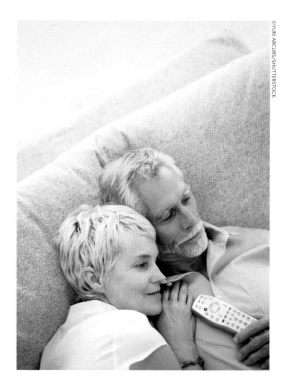

©YURI ARCURS/SHUTTERSTOCK

Lifestyle images dominate the royalty-free licensing models.

create images specifically for stock. Founder Tony Stone had an instinct for what art buyers wanted, and his instincts paid off: It wasn't long before TSI was working with many of the best U.S. and European photographers on fully funded productions.

As the industry became more competitive, it was no longer enough for a photographer to set out in his van for a day trip and come back with images that could be counted on to fund his retirement. The image became king. Likewise, outtakes from commercial shoots—previously a big source for stock imagery—no longer suited the growing need for photos targeted specifically to the commercial market.

In 1993, Mark Getty and Jonathan Klein started a new stock photo company called Getty Images, using Getty family money along with funds raised from stock offerings and private investors. Almost immediately they began buying up rival companies and ultimately took Getty Images public. (The company was made private again in 2008.)

Not long before, in 1991, across the lake from Corbis's office (then in

Bellevue, Washington), a little company called PhotoDisc was making strides. PhotoDisc appeared to be a technology in search of a product. It marketed CDs containing stock photos, and, since it was impossible to control the usage rights on a CD once it was distributed, the images were called "royalty free." The right to publish stock photos previously had been tied to a complex set of licensing rules and often involved intricate and confusing negotiations that resulted in expensive fees. The PhotoDisc model eliminated the time-consuming negotiations, and as a result, the fees were much lower. By the mid 1990s, PhotoDisc was the fastest-growing company in the stock industry; they were purchased by Getty Images in 1998.

By the early 2000s, stock photography had evolved into a highly exclusive, upscale industry, accepting only about one percent of the images submitted and charging users fees that ranged from $300 to $10,000 or more per image. Around 2005, the world's need for inexpensive visual content took a dramatic upswing, fed by fast, widely available broadband Internet connections and a worldwide explosion of blogs, websites, magazines, promotions, and advertising that required constantly refreshed visual content. Combined with a proliferation of high-resolution, inexpensive digital cameras, the response was a revolutionary new licensing model in the form of social communities supported by user members called "user-generated content" (UGC). Today, millions of UGC images are uploaded daily to sites such as Flickr, where under something called Creative Commons copyrights, some (though not all) images can be used for free. Those that can't be used for free are marked "All rights reserved." Microstock entered the picture by attaching nominal royalty fees to UGC as well as providing higher technical quality and model releases that are usually not found on Flickr or MySpace. A better moniker, in fact, would be "micropayment" stock because the goal is to license images for "micro" prices and gain revenue from the sheer volume of images sold.

◼ MICROSTOCK DEFINED

Microstock is defined by several criteria that, taken together, separate the model from all others:

1. It is delivered exclusively in digital format and licensed solely online.

2. It is open to a wider range of photographers than traditional stock licensing companies.
3. The images are licensed for very low fees, but often in much larger volumes than traditional distributors can generate.
4. Because the photo editors (called "reviewers") are not as demanding with respect to subject matter as photo editors at large stock companies, microstock collections have a very broad, deep selection of images across all subject matter, including even erotica (found in restricted portions of some sites).
5. Instead of long, legally complex contracts, microstock companies have online agreements similar to the user agreements for any website.
6. Images can be removed from circulation easily without waiting for years, as with traditional stock companies.

To begin selling images in microstock, you simply sign up at one or many of the sites, read the site's rules and regulations, and then upload your images. Assuming the images pass technical requirements and minor subject rules, they are posted on the microstock agency's website and

Simple images isolated against white are very popular in microstock collections because they are easily adapted to many designs and layouts.

©ALEXANDER RATHS/SHUTTERSTOCK

©YURI ARCURS/SHUTTERSTOCK

When a photo requires many models and an expensive location shoot, submit the resulting images to many microstock sites to earn a profit as soon as possible.

quickly become available in searches. Whenever a user downloads your image, a small licensing fee is credited to your account. Once the account has a certain level of funds, usually $50 to $100, you can request payment by either PayPal, check, or a custom debit card that some companies offer.

Today, the four largest microstock agencies are iStockphoto, Shutterstock, Fotolia, and Dreamstime. The granddaddy is iStockphoto, which is more selective than some of the others and takes the largest cut of the licensing fee. Shutterstock, as many photographers can attest, earns them the most money, and Dreamstime pays the highest percentage to photographers.

Many photographers recommend placing work with these four as well as some smaller microstock companies to gain maximum revenue. Others claim to do better by placing all their photos exclusively with one company, in exchange for a higher royalty. However, it should be noted that, unlike traditional stock agencies, which offer image-only exclusivity (where the

photographer can still place nonsimilar work with another agency), signing exclusively with a microstock agency requires that *all* your work be shown only with that agency.

▌ *UNDERSTANDING YOUR "RIGHTS"*

When a user "buys" an image, what the individual is actually purchasing is a *license* to use the image. A copyright is infinitely divisible and can be licensed again and again (under most circumstances). The creator of the image maintains ownership, unless the image is created as a "work for hire," which means that someone paid you on assignment to take that shot and that person or company retains the rights. Almost universally, licensing conditions prohibit the image from being used in pornography or in a defamatory way.

There are three major license types for all types of stock photography: rights managed, royalty free, and Creative Commons.

RIGHTS MANAGED

The price of a rights-managed (RM) license depends on a menu of options that restrict the usage of an image. License fees can range from under $100 for some editorial uses to six figures for exclusive, worldwide rights for use in advertising. (Such expensive licenses are rarely requested.)

The key attributes that can determine the licensing fee for RM images are:

- Type of usage (editorial or advertising/promotion)
- Size and placement of the image (cover, quarter page inside, etc.)
- Distribution (local, regional, national, multinational)
- Market sector (type of business or industry)
- Duration (length of time of the license)
- Degree of protection or exclusivity

For example, let's say a company selects an RM image for its international advertising campaign for a type of sneaker. The brand is well known across the United States and Europe. The campaign will be in print and on the Web. It will appear for six months in ten magazines in four languages. Four billboards will be placed for six weeks around New

York City before and during the New York City Marathon. The company requests multinational rights for six months and six weeks for outdoor (billboard) use with exclusivity restricted to sporting goods. The licensing fee for such an agreement could easily be in the high five figures, or more.

ROYALTY FREE

On average, royalty-free (RF) licenses are much broader and less expensive than RM licenses. Traditionally, the RF license is a fixed price based on file size. For less than $200 to $400, the buyer is free to use an image with few restrictions. Microstock is actually a subset of RF, with costs averaging $4 to $8, depending on file size and print run. Most microstock companies limit the number of times an image can be reproduced in a printed piece to between 250,000 and 500,000 copies.

If the shoe company in the above example selected an RF image, it wouldn't have to worry about exceeding the strict terms of the RM license. Of course, this also means that, without the exclusivity, another shoe company could use the same image at the same time.

CREATIVE COMMONS

If you follow Flickr and other photo-sharing sites, you will see some images marked with the Creative Commons copyright designation ⓒ . This means that the owner retains copyright of the image, though licenses are offered free of charge. There are a few different types of Creative Common licenses for photographs, all of which are normally liberal in scope:

- **For attribution.** You let others copy, distribute, and display your copyrighted work (and derivative works based upon it), but only if they give credit the way you request.
- **Noncommercial.** You let others copy, distribute, and display your work (and derivative works based upon it), but for noncommercial purposes only.
- **No derivative works.** You let others copy, distribute, and display your photography, but with no changes allowed, and it cannot be incorporated into other work to make a derivative piece.
- **Share alike.** You allow others to distribute derivative work only under a license identical to the license that governs your work.

Each of these licenses has a specific designator mark that is shown in addition to the Creative Commons mark. For more information about Creative Commons licensing, go to www.creativecommons.org.

If you license your image under a Creative Commons copyright, it doesn't mean you can't license the same image for compensation in the future. Some photographers upload only small files to Flickr under a Creative Commons license, keeping the higher-resolution files offline to license for a fee. Former Creative Commons outreach manager Fred Benenson recalls a situation in which Jeremy Keith, a Web developer in England, placed an image on Flickr under the Creative Commons Attribution license of NASA's vehicle assembly building. A film company wanted to use the image in a movie poster for the film *Iron Man* but didn't want to give Jeremy a photo credit. Since the license required attribution, the company offered Jeremy $1,500 for the privilege of *not* giving him credit.

HOW TO USE THIS BOOK

No matter what licensing model they use, all serious amateurs and professional photographers want to know what to shoot to maximize downloads

Highly conceptual images such as this were once available only as rights-managed licenses. Today they are available in microstock collections.

©BEATA BECLA/SHUTTERSTOCK

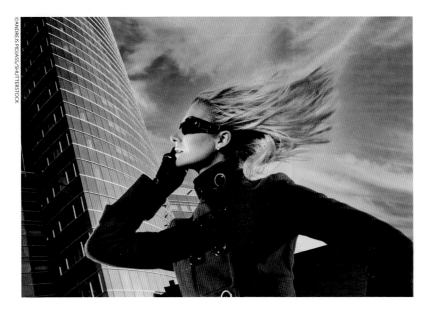

©ANDREJS PIDJASS/SHUTTERSTOCK

Some designers would be delighted to find this unique image in the search results for "woman on a cell phone"; others would opt for a more conventional image.

of their photographs. This book shares my more than thirty years' experience working with companies that specialize in stock and microstock business models to answer that very question.

This book is not about how to be creative, nor how to take technically correct photos. What it does do, however, is suggest which types of images the marketplace demands year after year. It is up to you to take those suggestions and create something new, combining commerce with art. If you have to sacrifice one for the other and wish to generate revenue, go for commerce. The motivation for someone to seek out a stock photo is usually that he or she thinks that photo already exists. Thus, like it or not, stock photography is a business of clichés. Highly unusual or artistic images may get used for marketing purposes now and then but are rarely licensed repeatedly. Speaking generally, the best stock photo is one that has already been shot.

Once you have a sense for what types of images are the most popular, read Chapter 11, which walks you step by step through preparations for a sample photo shoot, from conceptualizing a theme to finalizing the logistics. You might then want to go back and reread Chapter 2 for tips on making your first submission.

Good luck and—most importantly—enjoy the process!

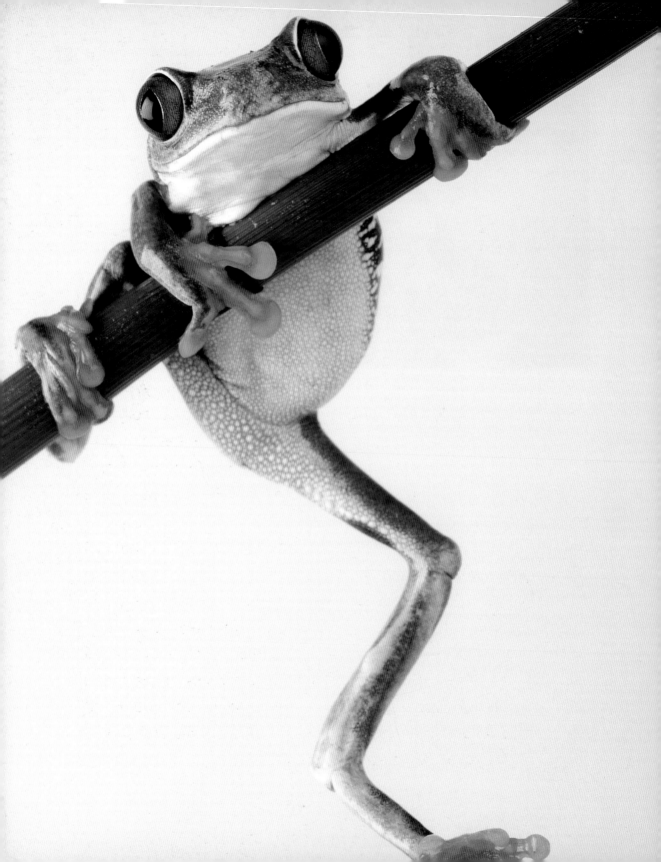

02

THE BIG PICTURE
STRATEGIES FOR
SUCCESSFUL SUBMISSIONS

If you are ready to enter the microstock market or improve your percentage of accepted images, there are several key points to consider. Maybe you have your first camera, or perhaps you are already part of a photo-sharing network such as Flickr and have improved your images with advice from others in the community. You may have gone as far as being up-to-date on photo editing and work-flow software. You may know lighting and Photoshop and understand all the technical wizardry of making photos. But even successful professional photographers are surprised when some of the photos in their initial submissions to a microstock site are rejected. Beginner or pro, your chances for succeeding in the microstock world can be enhanced by paying attention to some simple tricks of the trade. In addition to learning *what* to shoot, which will be covered in the chapters to follow, there are several general strategies one should employ to improve the chances for success.

◣ *STAY ON TREND*

In this book, I'll be discussing topics that are perennially popular in microstock. However, any topic still needs to be given individual treatment by the photographer, and your interpretation will make a big difference in whether the image feels timely or dated. The best way to stay on top of current trends is to do creative research. The goal is for your photos to incorporate popular colors, wardrobe, and accessories, and to reflect social trends by the time users start asking for them.

In the past, large stock production companies did creative research by subscribing to dozens of lifestyle, shelter, fashion, sports, and business publications. Magazines would be ripped apart, and the most appealing and fresh pages (known as "tear sheets") were taped to a wall in the creative department. Every now and then there would be a creative brainstorming meeting to analyze the tear sheets. This information would be combined with sales data to provide ideas for photo editors, art directors, and photographers. The process worked well for a while, except that all the competitors got the same magazines, and by the time the magazines were out, the trend was, too.

Here is how you can do creative research:

- Read the style sections of major newspapers, especially online, where you will come across visuals to stimulate your imagination.
- Watch TV and rent videos. Capture stills by stopping when you see a visual you like and taking a snapshot of the screen. Ask yourself why the image appealed to you. The answer may give you an idea for a shoot.
- Tear up magazines and visit websites on subjects that interest you (yes, that can still work as a source of inspiration).
- Go to art galleries and museums. Professionals who use photography also go to galleries and visit art collections for visual stimulation.
- If you feel you are too over the hill to tap into hot trends, take heart. New cultural icons, games, and trends continue to develop for all demographics—including older generations.
- Continue to learn new things. Want to explore educational innovations? Visit a modern elementary school. A friend of mine was amazed to discover that third-graders are now learning PowerPoint.

- Use your research. Let's say your research tells you that food made from ingredients from farmers' markets is popular. Go to the big microstock sites and search for "fresh vegetables," then sort by number of downloads. How can you improve the existing inventory? What can you do to make your images unique while staying focused on your subject?

- Completely out of ideas? Put the camera away for a few days and go for a hike, read a good book, or make a list of subjects that interest you that you haven't photographed. Imagine visuals as you listen to music. Take a point-and-shoot camera along wherever you go. Record anything that catches your eye. Don't analyze . . . until later, when you have distance from the subject. These can become your notes for what to shoot next.

▌ *EDIT YOUR WORK*

Professional photographers who enter the world of microstock often make the mistake of submitting work they would be ashamed to show on their personal website or give to a traditional rights-managed business. As the microstock business has matured and the world sees higher-end images on sites such as Flickr, the desire for quality has grown. Junk photos in the professional world remain junk photos in the microstock world.

There are hundreds of images out there of women getting facials with cucumbers over their eyes; nearly all are virtually identical. It was an appealing graphic and much sought after—until it was shot to death.

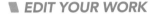

Photographers are rarely the best editors of their work—if they were, the world would need far fewer photo editors and reviewers. The fact is, even the best photographers can expect no more than a ten percent acceptance rate from a day's production, so be a tough critic of your work! Each upload costs you time, and your goal is to maximize revenue and minimize workload. This is good advice whether you are a professional submitting to a rights-managed company or an amateur taking the first steps to joining a microstock site.

Editing should take place at all stages of the photography process. Before you click the shutter, ask yourself why anyone would want to use your photo. Can you write a caption to the image? What does the image say to you? Is it humorous? Does it elicit emotion of any kind? Is it depicting a subject that is in demand? Is the light right? If you can't answer these questions in the positive, trash the image, or put it with other wallflowers in a safe place. You might like it later. If the love lasts, go for it and damn the rules.

When selecting your images for submission, first get an independent opinion by showing them to someone else. Ask what he or she thinks the photos are about; you might be surprised by the answer. This will also help you with keywords (explained in Chapter 10) because what *you* think a photo means may not be what it says to the viewer. Don't take praise from your peers in the microstock forums as confirmation of an image's success. Some people are eager to offer unwarranted praise in public forums—or they go to the opposite extreme with negative remarks that are equally useless, and morale-busting to boot. It's behavior that is found in the culture of many social networks; there's always a Pollyanna eager to shower praise on anyone's work. (Is Polly looking for a friend?) And equally present is the curmudgeon using the anonymity of the Internet to blow off steam with mean and unwarranted criticism of others.

It's important to upload only what you believe will sell. Your goal is to have images online that will be downloaded multiple times. On some sites, such as Dreamstime, the number of images that you can upload daily is restricted if your download ratio is low. And in some microstock companies, your placement in search results will suffer if your images are not downloaded often, so there are serious consequences of not editing your uploads carefully.

Is Your Gear Good Enough ?

Photographers tend to get hung up on their equipment (and I don't mean by tripping over tripods!). They believe that the most expensive cameras, lenses, and other doo-dads will increase the quality of their work. Shooting with your grandmother's ancient Kodak film camera may not give you marketable images, but neither will thousands of dollars of gear guarantee a high number of downloads. Successful microstock photographer Yuri Arcurs told me that one of the most important pieces of advice he gives to photographers starting out is to buy the "80%" equipment. Meaning, don't buy the latest, best monitor, lens, and camera. The top equipment is not necessary, and will be out of date next year anyway. Buy equipment a few levels down; you'll save money, and your images will be just as good.

◼ *FOLLOW SUBMISSION GUIDELINES*

You've done your research and edited your images, and you're ready to submit them.

Here are a few suggestions for your first try:

- Read all the information about submitting on the microstock agency's site before you upload and then follow the directions.
- Limit the first group of images to no more than thirty. This way, if you made major mistakes, you won't have many images to correct. You will also limit any restrictions on your upload limit.
- Don't use your image number as the description or caption.
- Make certain your model release is witnessed, as most microstock companies require.
- See the sidebar on page 30 for a checklist of more common errors to avoid.

◼ *LEARN FROM YOUR REVIEWS*

A microstock company's official review can be brutal. Successful, professional stock photographers are often angered and shocked when a microstock reviewer rejects images that are technically equal to those that have been accepted by traditional rights-managed or royalty-free companies. The reason is that the way images are reviewed at stock and microstock houses differs a great deal. Traditional stock editors look at content first, and then images are passed on for a technical review and are often fixed by in-house staff. But the low price points and business model of microstocks don't allow that luxury. So the best response is to bury your ego, listen to the criticism, and fix the picture.

Owing to the international nature of the microstock industry, and the fact that image reviewers are located all over the world, reviews will differ based on each company's needs. There are also inconsistencies in the technical selection process. Images that are rejected by one company may be accepted and downloaded many times on another. As you get a few hundred images approved in the microstock world, you will get a better sense of which of your images are the most popular, and why.

■ Common *Submission Errors* to Avoid

The following is a list provided by Shutterstock of common submission errors.

IMAGE CATEGORIZATION

- Images haven't been categorized correctly.
- The "holiday" category is incorrectly used for vacation/travel imagery.
- The "celebrities" category is incorrectly used for celebrations such as birthdays and Valentine's Day.

IMAGE QUALITY

- Images are submitted upside down or sideways.
- There is a watermark or date stamp left on an image.
- There is a frame around an image.
- The image is out of focus.
- The depth of field is too shallow.
- Composition is poor and/or there are cropping issues.
- The image has too much "noise" (visual and color distortions similar to excess grain in film). Submitters should view images at 100% prior to submitting to check for noise and dirt.
- A previously rejected image is being resubmitted without the necessary corrections.
- Images have not been well edited. (Some submitters send in hundreds of unedited images at a time and wonder why ninety-nine percent of them are rejected.)
- Poor isolations in situations when the photographer went back to the image to make the background white/whiter after the fact.
- A dirty lens or sensor was used, and the submitter hasn't cloned out the dust properly.
- Lighting issues. (Some images are simply not lit well for stock use. They are over- or underexposed, have deep shadows, or have burned-out areas.)

TITLE/KEYWORDS

- Keywords are used in the titles of the image. (Titles are what are sometimes called captions.)

- Camera information is in the title.
- Keyword spamming is present (see page 139).
- The term *logo* has been used as a keyword or in the title. (Shutterstock does not license images for logo use.)
- Titles are poorly written and descriptions include misspellings, typos, or foreign-language words.

EDITORIAL
- Caption format for editorial images is incorrect.
- No caption is provided.
- Non-newsworthy images are submitted as editorial.

MODEL RELEASES
- No model release is attached.
- Model releases are not submitted in the proper format; upside-down views are most irritating to reviewers.
- Model release is incomplete, lacking a guardian signature for a minor, or not signed at all.
- The photographer or model has signed as the witness. (The witness signature must be a third party altogether, even for self-portraits.)
- The model release is not in English. (Dual-language model releases are fine.)
- Images of the photographer's children do not include model releases. (Yes, they still need them.)
- Model release is not legible.

■ BUILD A CORE COLLECTION

Once you have submitted work, the next step is to begin building a core collection. The best way to do so is to concentrate on what you know. I have never forgotten a George Booth cartoon that perfectly illustrates the point. A frustrated man is sitting at a typewriter on the porch of his dilapidated cabin, surrounded by dogs. His disheveled wife appears at the door and offers this advice: "Write about dogs." If you are a dentist, shoot a model in the dental chair, post dental X-rays, photograph your equipment in use, or have your employees sign releases and then photograph them in the office.

Build a deep collection of images around a subject that interests you. Love roses? Take photos of roses—but since floral images are some of the most uploaded on the Web, ensure that yours sparkle and consider taking images *about* roses, such as close-ups of garden pests, the act of pruning, or the planting of a rose garden.

I recently reviewed the portfolio of a young photographer a few months after she graduated from a well-known photography school. She showed me a book of fashion images, which were well lit and beautifully styled. The makeup was perfect, as was the selection of models. However, the photos were instantly forgettable; I had seen them thousands of times before. She had shot what she believed the market wanted without considering her own interests. I put her portfolio aside and asked, "What do you *really* want to photograph?" She said she loved taking pictures of mountains and pulled out another set of prints. Things were quickly getting discouraging, as these images were even more lackluster. But the images would have been perfect for stock sales had they included a human element. I pointed out how a hiker or climber (even very small in the image) would improve her stock sale potential. She was excited about the prospect and was on her way to combining her passion with a marketable genre.

❧ *MONITOR YOUR RESULTS*

Lee Torrens, creator of the respected blog Microstock Diaries, advises photographers to monitor the success of their portfolio by using a metrics system called "return per image," or RPI. Monitoring the RPI for various aspects of your portfolio will help you know which photos earn the most and enable you to expand on your strengths. Microstock agencies provide enough real-time data for you to know exactly how each photo, shoot, and portfolio is performing and track the performance over time. To calculate RPI, divide your total monthly revenue by the quantity of images in your portfolio or the portion of the portfolio you want to measure. Unless otherwise specified, RPI is usually calculated and expressed in monthly terms.

Many microstock photographers use the conveniently round figure of $1 as an average RPI. This average takes into account the effects of seasonal trends and structural changes at microstock agencies. It's also heavily influenced by factors in each contributor's account, which impact

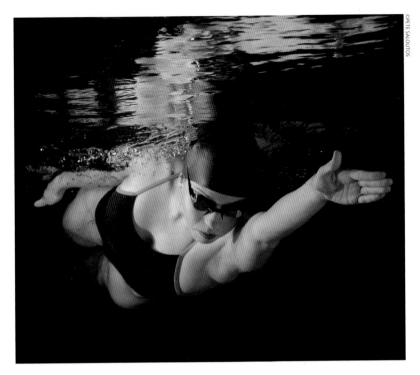

©PETE SALOUTOS

Pete Saloutos has combined a passion for swimming with a creative, marketable photographic approach, seen in this best-selling image.

placement in search results. Therefore, when comparing yourself with this average, Torrens advises you to take all factors into account, especially the demand for the subjects in your portfolio, how long you've been contributing, the size of your portfolio, and the past sales performance of your images. A very high RPI in microstock is $5; few contributors generate more revenue. It is important to note that RPI is about income, not profit. A shoot or photographer with a higher RPI—but also higher production costs—may not be any more profitable than another shoot or photographer with a lower RPI and lower costs. Collecting and tagging these data can help you assess all aspects of your photography: the subject, models, locations, and their respective styles.

New companies are appearing to help make this process relatively automatic and easy. They include iSyndica and LookStat.com. They enable microstock contributors to automatically download and combine information from various microstock agencies. LookStat CEO and founder Rahul Pathak says that photographers are often surprised when his analytics show that the images they thought were their best sellers actually aren't.

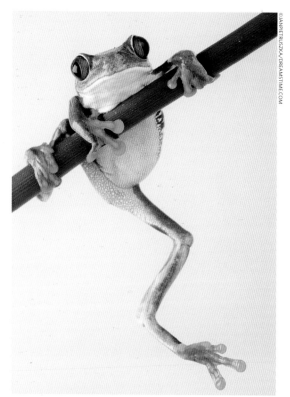

©JANPIETRUSZKA/DREAMSTIME.COM

This photographer, known as Janpietruszka in the microstock world, is the go-to guy for wonderful images of the comical red-eyed tree frog. Janpietruszka has built a microstock brand with this singular subject matter.

▪ Know **What** You're **Shooting**

Sometimes it's difficult to grasp why certain photos sell and others do not. One photographer I know showed several photos to a group of professional photographers and asked them why a few of his images on very hot topics had undersold other images from the same shoots. One was a photo of two doctors looking at an X-ray. What the photographer hadn't noticed was that the "doctors" were holding the X-ray at waist level, gazing down at the film, whereas in reality they would never do so, as they wouldn't be able to see its details. Always have a person who knows the subject with you when shooting medical or technical subjects.

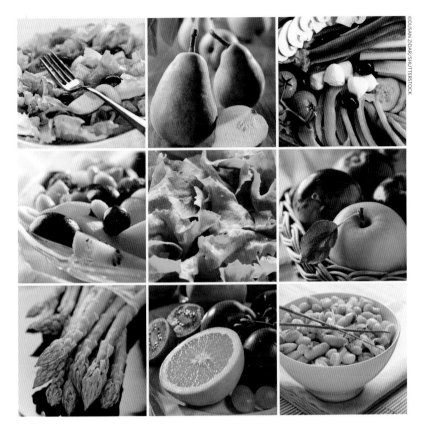

A collection of images that relate to a healthy diet offers the buyer many options to illustrate a best-selling category. This collection is available as a single download.

▌ *RESEARCH YOUR COMPETITORS*

Another piece of advice from Lee Torrens is to monitor the strategies and progress of your competitors, which is easy to do, thanks to the open nature of microstock sites. This can work to your advantage by enabling you to learn, grow, and gain inspiration. However, this practice can also work to your disadvantage when your own concepts or style are copied by other photographers.

Most microstock contributors quickly discover the portfolios of the top performers, as well as find their own favorites. Viewing their portfolios and sorting by date allow you to see how their skills and style have

developed over time. Doing so also provides a method for monitoring their new contributions.

Microstock agencies also provide information that can be useful in getting to know other contributors and what's selling in the market. This includes top-selling photos, top-selling contributors, which contributors have the largest portfolios, and which contributors are uploading the most new material. The location and structure of these lists change frequently, but they're easy to find on the home pages of each agency.

iStockcharts.de draws information from the iStockphoto website each day in order to rank contributors by various metrics. The system allows you to sort by total sales, recent sales, sales per image, portfolio size, and various other, more complicated metrics. If your account isn't on the monitored list already, you can add it via the website to see how you compare with other iStockphoto contributors.

Words of Wisdom

Serban Enache, CEO of Dreamstime, offers the following suggestions for those just starting out:

- **Be motivated, but also patient.** In other words, trust the system to help you be successful, but don't expect results overnight.
- **Submit only quality images.** Do your research to be sure you are submitting stock-oriented themes and creative concepts.
- **Submit a variety of images.** Quantity is not the same as diversity in your portfolio. Edit drastically to eliminate too many similar images.
- **Always aim higher.** Learn from rejections to continually improve your skills.
- **Take photos!** Allocate a significant amount of time to honing your craft.
- **Invest in your gear.** Reinvest your revenue into continually upgrading your equipment.
- **Follow the rules.** Read the agency's website as well as industry forums and blogs to understand the rules.

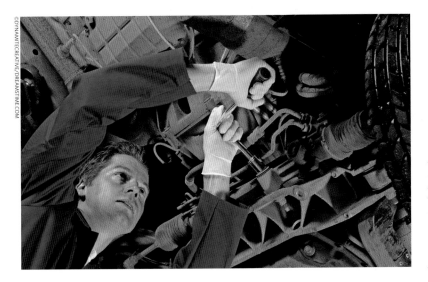

©DYNAMITECREATIVE/DREAMSTIME.COM

Any time you're shooting a medical or technical topic, ask a person who knows the field to act as consultant. Clearly, an experienced auto mechanic would know if the man pictured was using the correct tools to perform a believable task.

🔖 BUILD A BRAND

The highest-achieving microstock photographers have learned to increase their number of downloads by developing a fan base among regular users. They start with the best practices in lighting, composition, choice of subject, and keywords. Then they go a step further and develop specialized niches and an identifiable style; this leads to the building of a recognizable brand. Users come to identify a photographer whose work they appreciate. Since most microstock sites allow users to search directly within portfolios, users will often bypass the general searches and go directly to the images of their favorite photographers to the exclusion of others.

Jan Will Martin is known as "Freezingpictures" in the microstock world. His photos of penguins are widely used and represent his brand. I asked him how he came to be a photographer famous for shots of penguins. He responded:

> To focus on penguins and develop that niche was an obvious step for me. I'm a helicopter mechanic, and the company I was working for sent me to Antarctica on a research vessel loaded with two helicopters. I always liked photography, and it was the perfect trip for taking photos, but at that time I did not think I could make money with the photos. A year later someone brought my attention to iStockphoto, and shortly afterward I

Quick Tip:
Your competitors are also your colleagues. Jon Oringer, the CEO of Shutterstock, recommends interacting with other photographers to help you refine your style. He advises photographers to participate in the forums on his company's site, saying, "Our users are very generous with their time and advice. Learn from colleagues who will welcome you with open arms."

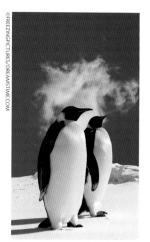
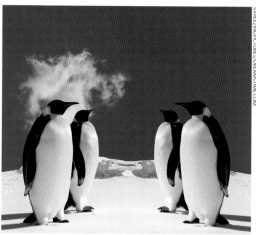

Jan Will Martin added a blue sky to an image of penguins to turn a bland image into a best seller that tied into his brand. When he went further and doubled the effect, he created another popular image.

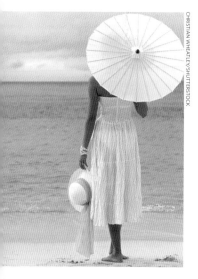

Christian Wheatley's portfolio is the place to search for photos of beautiful women on Caribbean beaches. Wheatley's images are consistent in style, and the subject is a popular one for use in travel-related materials.

found out about Dreamstime and Shutterstock. Among my first uploads were the penguin pictures, uploaded much the way they were taken. They didn't earn a lot of money, but I was hooked. Slowly I increased my portfolio. Soon all of my best photos were online, and I had no more penguin photos to upload. It was obvious that penguins were selling better than the rest of my photos, so I found a way to create more without traveling back to Antarctica—Photoshop. I made my first penguin photo design with penguins from Antarctica and a sky from California. That is when my sales really started to pick up. I continue making new designs; some are more successful than others, but on average they earn much more per image than most other themes.

Martin turned a single trip into photos that will generate revenue for years to come, as well as a branded identity. Other photographers specialize in a certain sport or a geographical area. Users with recurring needs for a specific subject or style immediately go to the portfolio of a photographer whose work they know will consistently satisfy their requests.

The downside to developing a recognizable style is, of course, that it may not turn out to be a popular one. For example, several active microstock

photographers insert large burned-out sun glares into every image. I skip over these images because I don't like the effect. I have searched on these photographers' portfolios and noted that they haven't uploaded the original image without the artificial sun, so I no longer browse their portfolios. I can say the same for the water-reflection effect, which has been overused, as well as overly saturated images and those with a heavy-handed application of Photoshop.

IncreasingTraffic

Here are two quick tips for diverting traffic to your microstock portfolio:

- Donate an image to the free section available on most microstock sites. The theory is that the free image may increase interest in your portfolio as a whole, resulting in more downloads.
- Introduce your photography to potential users by building a following on Flickr. If a user likes the free images found there, he or she may go to your microstock portfolio to see the pay-to-use images, or may contact you to license an image.

This useful concept image was downloaded from iStock as a freebie.

Shutterstock offers a single photo each week as a free image. Once the week is over, the photo returns to the photographer's portfolio as a regular fee-based image.

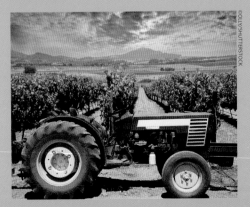

03

WHAT TO SHOOT—AND WHAT *NOT* TO SHOOT
AN OVERVIEW

At this point, you may feel like a painter facing a prepped blank canvas, or a writer trying to find the first sentence in a novel. What will you create? Hopefully you have studied the microstock sites and developed ideas about what is popular; fits your interests; and suits the locations, models (or lack thereof), and level of your equipment and expertise. Before you move forward in a big way, you should submit a few images to two or three sites to ensure that you will be accepted and that you know what you need to do technically to improve your work. Keep in mind that simply because you love taking photos of your children doesn't mean that your photos will be accepted if you are sloppy in your editing and image cleanup.

▮ *WHAT NOT TO SHOOT*

Let's begin with what you *shouldn't* shoot. The following categories are offered as general guidance gained from years of experience, though there are always exceptions. If you have solid evidence that your images in the following categories beat the best, or you are shooting for pure pleasure and don't care about downloads, then these suggestions may not apply to you.

Here are subjects to avoid:

- Single flowers, unless the images rival the floral-themed paintings of Georgia O'Keefe or they are included in illustrations of broader subjects.
- Clouds, unless there is a tornado lurking among them.
- Shadows, especially of yourself taking a photo of your shadow of yourself taking a photo . . .
- Non-model-released images of people, unless you are submitting to a venue that accepts images for editorial license or a news section.
- Photos of art, whether in a public place or on a wall in the background, unless you submit a property release—even if you own the painting.
- Walls with peeling paint, a favorite subject for some reason!
- Your feet.
- Images that show trademarks or logos; even the arrangement or color combination of stripes on sneakers can be problematic.
- Your pet, unless the animal is very ugly, really funny, and unbelievably cute or is a prop in photos with people. A photo of your sleeping cat is especially boring.
- The sky outside an airplane window.
- Sunsets and sunrises. One or the other is going on somewhere on the earth all the time. If you are drawn to the sun, expect rejects, unless the image is spectacular. It helps if there are famous landmarks or people in the image . . . and a beach.
- People whose faces are obscured by poor lighting.
- Shots that feature electrical plugs, highway driving, or telephones, because they will be limited to use in countries where the driving is on that side of the road and the plugs and phones are familiar.

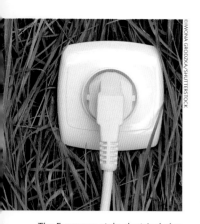

The European-style electrical plug in this clever illustration of the concept "green energy" might limit the image's use.

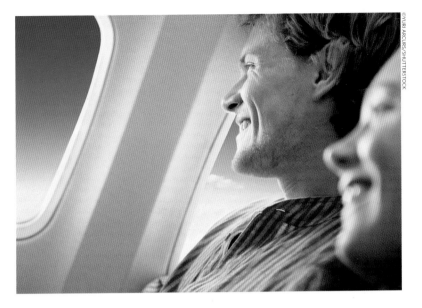

Every rule has an exception. Microstock companies don't want images taken out of airplane windows . . . unless the images show happy passengers.

- Close-ups of fire (though an interior that includes a blazing fireplace or a disastrous house fire will suit the reviewers).
- Extremely artistic images that might make great art but don't have commercial value.
- Boring images—you know what they are. Don't fool yourself.
- Any subject that is either very common (see "flowers" on previous page) or, alternatively, too strange or weird to attract multiple buyers.

▋ *WHAT TO SHOOT*

Samuel Johnson stated that there are only seven possible themes in fiction. There may be slightly more in stock photography, but essentially the same dozen or so subjects are what sell over and over. Variations on these themes evolve along with trends in lighting, fashion, and social issues, but the basic themes remain the same. It is the challenge of the stock photographer to find his/her own voice (style) within these broad notions.

©FOTOLISTIC/SHUTTERSTOCK

Microstock companies routinely reject shots of flowers, but this snail's-eye view of a garden was unique enough to make the cut (*right*).

Mikael Damkier has created best-selling images using common household fish, but since pets are accessible to most photographers, the genre is overrepresented in most microstock collections (*below*).

©MIKAEL DAMKIER/SHUTTERSTOCK

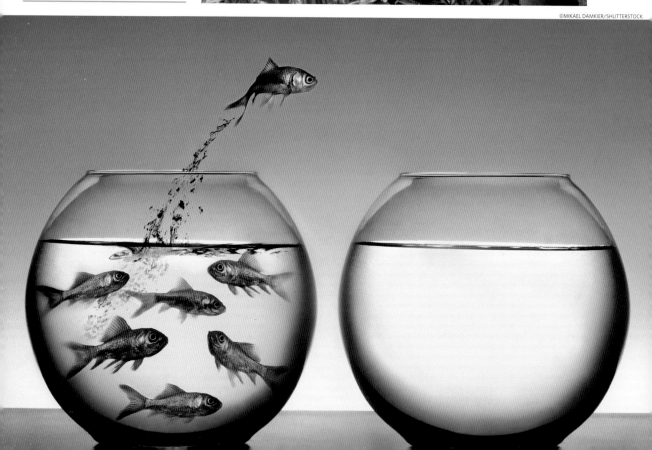

Major themes in commercial stock photography include:

- Couples, especially relaxed and happy ones.
- Families of all ethnicities (usually with two children and a pet).
- Business and commerce, including office meetings with a group of people. Professions, especially in the medical industry.
- Travel to both remote and popular tourist sites with model-released people.
- Sports, both team and individual, amateur and professional.
- Manufacturing, industry, and agriculture, particularly when involved in energy conservation, green farming, and solar and wind energy.
- Natural disasters, especially those covered by insurance, such as floods and fires.
- Food and beverages that are appetizing and shot against white backgrounds.
- Locations, chiefly the major world cities, but remote rural scenes are also important.
- Animals, both domestic and wild, and peaceful nature scenes.

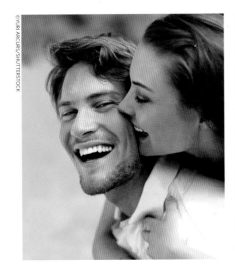

Photos of young couples are more successful when the models appear relaxed and happy.

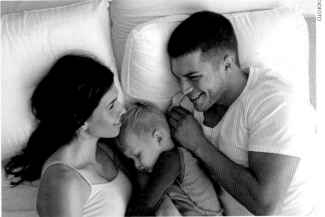

This couple is relaxed and the child appears to be asleep, making this a believable and thus appealing image. Pay close attention to your models when you are attempting to show them sleeping; too often they can look like they are awake or, alternatively, comatose.

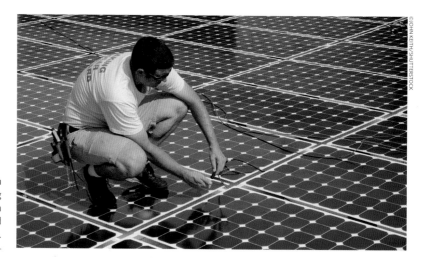

Industries that support clean energy will be in demand during the coming years, more so than "old" manufacturing and refining businesses.

Armed with this limited number of basic themes that sell, how can you avoid being an imitator? Do what you can to give the themes a fresh spin. Search for unknown models, replace standard business attire with wardrobes with a little flare, and ensure that computers and other electronics are the latest models. Think about real-life situations rather than photos you have seen. Tell a story rather than simply place your models in front of the camera. Personal style not only distinguishes your marketable images from others on the same subject, but shows that you have the talent to create individual, unique work. Don't be a copycat; respect copyright.

Historical and cultural locations are a must for travel photographers, such as this bamboo grove in Kyoto, Japan, near the famous Tenryu-ji Temple, a World Heritage Site (*below*).

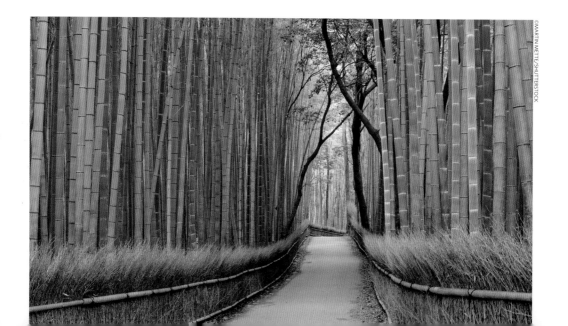

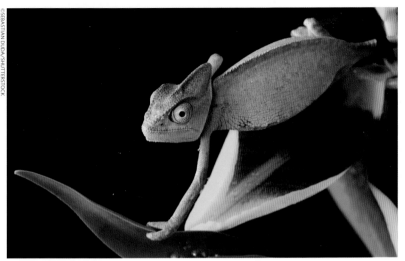

Chameleons, one of the most colorful lizards, appear in scientific editorials and in advertisements for color printers and other equipment where faithful reproduction of color is an important selling point.

The most mundane of all stock photos is the business handshake. Here, the photographer created a unique image by shooting from above. Shooting from unusual angles is a good trick to elevate your images above others.

You don't always have to re-create the most downloaded images to succeed; obscure subjects may find an occasional buyer. But the stock photo business is a numbers game. The more downloads, the more income. You want to develop specialties but at the same time have a diverse portfolio. And that's what the rest of this book is all about.

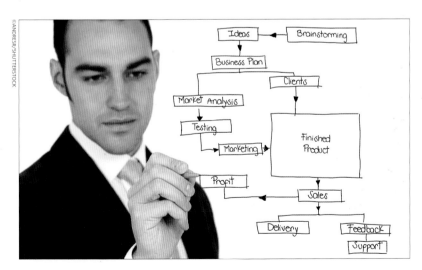

Andres Rodriguez, a successful microstock photographer based in London, has proof that it's important to photograph original treatments of common themes as well as neglected but important subjects. This best-selling photo of a database designer writing on a clear surface is an example of a subject that he discovered was neglected while searching for another image for a client.

FRAMING THE PERFECT PICTURE
COMPOSITION TIPS FOR BEST-SELLING STOCK PHOTOS

Anyone who tells you he or she understands *the* perfect, universal photographic composition has spent too much time in art school. Schools teach the rule of thirds, color theory, the triangular placement of subjects in classic painting, and other theories, all of which do have their place. But once you understand these rules, let them slip into your subconscious, where you'll use them without thinking. Too often a conscious dependence on rules will produce stilted, uninspired images. That said, there are some compositional guidelines that nearly all best-selling stock photos share. When these techniques are combined with fresh approaches to the popular themes listed in Chapter 3, they will give your images the best chance at being noticed.

▌ *ROOM FOR MULTIPLE INTERPRETATIONS*

A key compositional element of a successful stock photo was first articulated by industry pioneer Henry Scanlon, a founder of Comstock, when he coined the phrase "A good stock photo is an incomplete one." What Scanlon meant was that, for a stock photo to be useful, it needs to allow for many interpretations. If the concept is too obvious, the photo will be limited in its usage possibilities. But if the photo leaves room for mystery, and multiple interpretations, it becomes a "crossover" image that could work well for many more possible users.

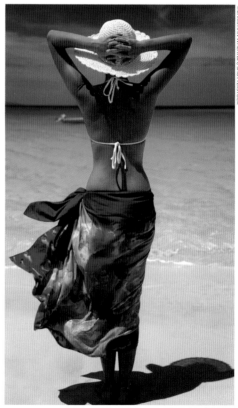

This mysterious image could be used to communicate many things once paired with advertising copy or a product announcement.

This image embodies the freedom and relaxation of a vacation at a tropical beach, as well as concepts such as female independence, peace and serenity, and good health.

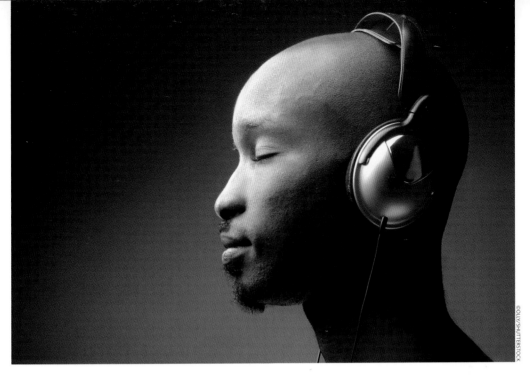

This man could be listening to music, learning a new language, or meditating while listening to white noise in order to block out the world. The facial expression and plain background support the abstract concepts of sound, concentration, and peacefulness.

❚ NEGATIVE SPACE

A corollary to Henry Scanlon's advice, noted on page 50, is the need to leave room for text or other artwork. In fact, on many stock photo sites, a user can search on images that leave "room for type." This suggestion is important when shooting images for publishing and print advertising. The art buyer or photo editor must be able to insert titles and/or place products into the image's negative space.

Imaging success in microstock often depends on simplicity. Subjects isolated against a white background provide the user with a blank slate and allow for a variety of design tools to be used in a final layout. Objects or people set starkly against white are not nearly as popular in traditional RM and RF collections.

❚ HIGH IMPACT AT THUMBNAIL SIZE

Anyone finding your photographs in search results will see them among a page full of others, all at thumbnail size. If you don't catch the eye in

the three to five seconds the average viewer spends looking at search results, it's not likely your image will be clicked through to the larger format and downloaded. You need to dominate the available "real estate" on the screen. Before digital cameras, stock agencies did this by creating a larger duplicate of the original 35mm slide to gain more space on an art director's light table and to stand out from the smaller 35mm slides. You can get a similar advantage by creating or shooting square images.

The space for thumbnails is a standard shape to accommodate a variety of formats. In a 35mm horizontal-aspect-ratio thumbnail, the image fills the width of the thumbnail, but not the height; the opposite is true for a vertical aspect ratio. To gain maximum space in the thumbnail area, use a camera that shoots square format, crop your image into a square format, or clone parts of the image to extend it to fill a square.

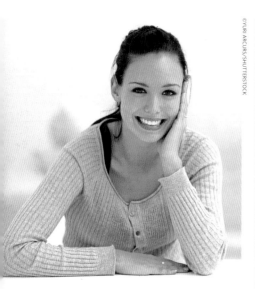

This model has an open, authentic smile, and the photographer has left ample negative space for type or product placement, making this an ideal photo for advertising.

Leave blank screens, empty billboards, and bare signs in your photos so that end users have an empty "canvas" upon which to place their own message or image.

The thumbnail of the image will appear larger than others and attract the browser's eye.

Impact when seen at thumbnail size is also a criterion you should use when selecting which images to submit to a microstock agency. Use editing software that allows you to preview at least twenty of your images at a time as thumbnails. Which ones jump out? More often than not, they will be simple compositions with large areas of color or a quick emotional "read." If your photo doesn't sell itself at the thumbnail size, it will get overlooked. When you're done, go back and view the entire selection one full frame at a time to be sure you haven't missed any winners.

If you find this technique too limiting, you're not alone. Photography industry blogger Paul Melcher bemoans the thumbnail-driven image and posted a thumbnail of Ansel Adams's *Moonrise over Hernandez* to prove his point. Of course, most great images do look better as large prints. And I agree with Paul that shooting purely to satisfy rules of composition can compromise your images, even though it may increase their income potential. I call this process "thumbing down," because optimizing composition for thumbnail views can mean that images have to be dumbed down by eliminating details in order to read in miniature.

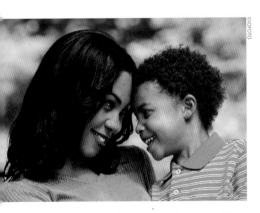
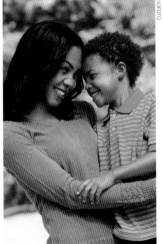
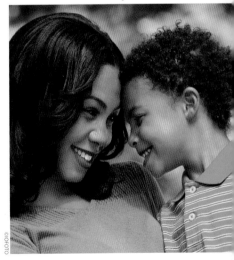

The vertical version of this image will leave unused space at the top and bottom of the thumbnail, while the horizontal version will leave unused space at the sides. The square format fills all the free space and will stand out from vertical and horizontal selections in the search results.

©ALENA OZEROVA/SHUTTERSTOCK

Closely cropped head shots of people and animals have more impact at thumbnail size, though this also limits their use because the buyer has no room to add type or his/her own crops. Many photographers wish stock companies would allow them to present both cropped and uncropped versions. Of course, you can upload both and hope they are each selected.

◣ EFFECTIVE LIGHTING

The best photographers know that light is either their best friend or their worst enemy. If you can't control the light, or recognize when natural light is good and when it will sabotage your image, you may need to hone your lighting skills by taking classes or observing a good photographer at work.

It is beyond this book's parameters to offer specific lighting techniques, but I would be remiss not to emphasis the importance of light. One of the best places to learn about lighting is from David Hobby, the expert guide behind www.strobist.com. He offers a DVD-based course in lighting that includes *Lighting Gear for Beginners*, four educational and extremely valuable lighting seminars and bonus material with how-tos on such challenging lighting assignments as "Lighting Indoor Basketball" and "Pool Portrait." Ordering information is available on the Strobist blog at http://strobist.blogspot.com.

The best natural light is available from the crack of dawn until mid-morning, when lazy photographers are finally creeping out of bed, and then again from the late afternoon to dusk, when many of your compatriots will be looking for the best place to spend happy hour!

I first recognized how an appreciation for beautiful light permeates a photographer's life in a conversation I had years ago with *National Geographic* photographer Mike Yamashita. I was planning a trip to Florence, Italy, and called Mike for restaurant recommendations, as he had spent considerable time there and had a passion for great food. With each recommendation, Mike indicated the time of day when I should dine at that

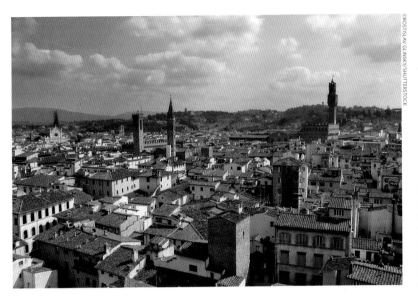

©ROSTISLAV GLINSKY/SHUTTERSTOCK

Every city has its best moments of the day. Wherever you're shooting, find out the times of sunrise and sunset as well as the orientation of the sun to the exteriors you plan to shoot.

particular place. I soon learned that it wasn't because lunch or dinner was better at one establishment or another, but because the *light* would be perfect at the allotted times.

◾ COMPOSITION NO-NOS

In addition to the guidelines above, there are some compositional errors that merit specific mention. These are best avoided in any photograph.

- **The painful crop.** Generally, it's best not to crop off the hands and feet of a model, nor the ears of a rabbit. Avoid such radical surgery unless you think it looks good—which it rarely does.
- **The unforeseen pole.** Amateur photographers inevitably position their model in front of a telephone pole, so the pole appears to emerge from the model's head or body. My father shot thousands of family photos, but instead of poles, he tended to photograph us with a tall cactus or tree growing out of someone's head.
- **Half faces.** Portraits showing exactly half a face were once popular—now, not as much.
- **Telephone wires.** Many a photo has been ruined by the photographer not noticing lines of electrical or telephone wires crisscrossing

©NIDERLANDER/SHUTTERSTOCK

This is a perfect stock photo gone wrong because of a poor crop. Is her right hand holding the drink? If so, she must have very long and flexible arms. The cropping adds confusion to the photo.

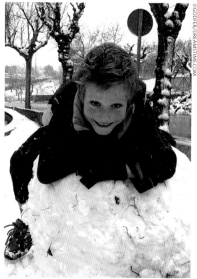

The harshly cropped composition of this portrait was popular for some time. However, it limits room for copy and as a style is losing popularity.

I contacted the photographer who took this charming shot of a young boy in the snow and pointed out that the image would be more successful visually if the stop sign were removed. He agreed.

the image. Fortunately, you can remove these visual distractions in Photoshop or other postproduction software, which is a must.

- **The Dutch tilt.** Holding the camera at an angle to the horizon was a trick developed by cinematographers to create an ominous mood. The technique then became a popular way for still photographers to provide visual relief when straight horizon lines became too monotonous. Now it's an overused compositional style that you should leave out of your bag of tricks on most occasions. The only time it is welcome is in the context of food photography, to relieve the viewer of seeing nothing but straight-on shots of plates of victuals.

- **The faraway view.** Images in which the major subject, such as a wild animal, is far away and shot with a 50mm lens are simply confusing. Is it a dog? A lion? A cow? A mouse?

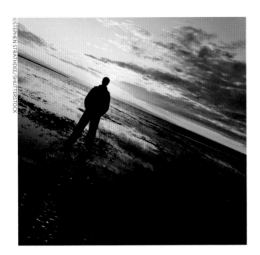

©STEPHEN STRATHDELE/SHUTTERSTOCK

Holding the camera at an angle known as the "Dutch Tilt" can change the mood of a composition. The image with the slanted horizon line feels more foreboding than a similar one shot straight-on.

◼ *Learning to See*

All photographers need to learn to see. I mean *really* see. Take a class in painting realistic still life and you'll get what I mean. The artist begins with a rough sketch, going back again and again to refine and add details. As the painter returns to the subject, more and more details are revealed and the painting becomes more realistic. Training your eye will enable you to see particulars you might otherwise miss, such as a carelessly buttoned shirt or a small stain that will take time in postproduction to remove.

Photographer Jay Maisel has enjoyed great respect as both a commercial and stock photographer for many years. At the beginning of his career, an art director told him he was "walking too fast." He later came to understand what that meant and offers the following advice:

> When we shoot, we should savor what goes on in front of us, allow things to develop, anticipate things, and not be in such a hurry to move on to however much more we can see quickly and superficially. It's all there if we take our time and look. Things have a way of happening in front of you. Standing still is also a good way of covering things; just let the world come to you. To paraphrase an old cliché: Don't do something; just stand there. Be patient.

POPULAR THEMES
WITHOUT PEOPLE

Thanks to the diversity of the Internet, the owners of websites and blogs download microstock photos on a much wider range of subjects than users of traditional commercial RM and RF images. Some types of photos that do much better on micro sites than on traditional stock photo sites include simple rural scenes from all over the world, objects isolated against white backgrounds, and still-life images.

I had a personal experience that highlighted the importance to the microstock buyer of searching a diverse collection that contained more than standard model-released lifestyle images. I needed a photo of a coyote crossing a road to illustrate a newsletter I was writing for a condominium association. The road to the condo project passed by a large nature preserve, and I wanted to tell readers to use caution while driving there because wild animals were being hit by speeding cars. I found the photo I needed on Dreamstime. Searching the two largest traditional stock sites, on the other hand, returned only a page each of images, none of which worked for me.

Some of the best sellers in microstock remain close cousins of the most popular images in traditional stock collections. As a result, I have worried that as microstock photographers begin focusing exclusively on reshooting only the most popular photos, their variety and creativity will be sacrificed. Jon Oringer, the founder and CEO of Shutterstock, put this fear to rest. He believes that by opening up the monetized licensing of photography to the world of amateurs and semipros, microstock has established the most creative stock photo venue in the history of the business. Images not accepted by most traditional agencies are now finding buyers. The following are the most common themes that do not use models or people.

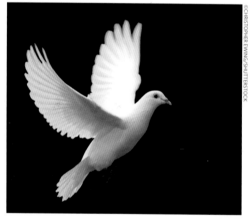

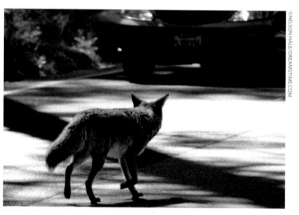

Pared-down images are often the most sought after on microstock sites. This one, of a dove in flight, is one of the most popular of all microstock photos.

The ready availability of images over the Internet has fed demand for obscure, editorial images not available anywhere but in microstock. This one, for example, was used to illustrate an article in a small condominium homeowners' newsletter.

Users of expensive, traditional stock photography might be surprised to find such a complex, dramatic photo in a microstock portfolio. This is an important concept image because "danger," "fear," and "vulnerability" are common search words.

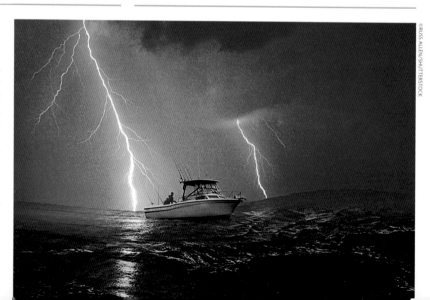

◣ TRAVEL IMAGES

Travel, or destination, images differ slightly from landscape photos in that they demonstrate a strong sense of place and often depict regional food, architecture, and other elements that speak loudly of an interesting and attractive place. Before you book an expensive trip to expand your collection of travel images, however, look around you. Your hometown is probably a destination for some vacationers. The closer you are to a popular place, the more likely you are to feel that you have exhausted it photographically. But in my experience, the opposite is often true.

Treat your city like a tourist destination and cover it completely before you set out to photograph somewhere else. You need to do all the same research and other preparation but need not worry if you forget a critical piece of equipment. You'll be in town for all the major annual events and celebrations, and you can eat at home. (One of the most common distractions for travel photographers is bad food, which often results in a few days confined to a hotel room.) You are presumably home most of the year and don't need to hang around extra days for the weather to clear. It's also a great place to gain skills; many of the lessons you'll learn photographing your hometown will serve you well once you do hit the road.

Try covering your hometown's annual events, such as this Caribbean Day parade in Toronto.

What seems an exotic location to one person is someone else's backyard. Travel photographers don't always need to venture great distances to get the images that clients crave.

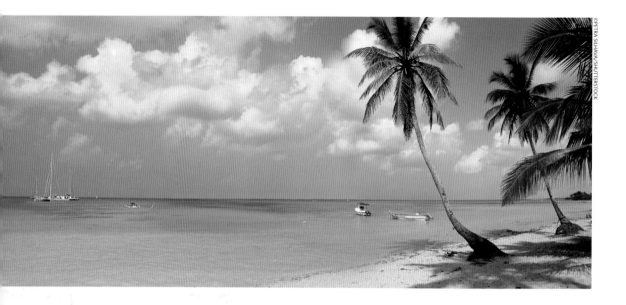

The exact destination in this photo isn't mentioned in either the keywords or the caption: This is a mistake. Sometimes users need images of a specific location, and if the information isn't supplied, they won't find or be able to use your work.

Renowned stock photo agency owner Tony Stone believed there were only a dozen or so important images in any major tourist destination. He instructed his editors and photographers to concentrate on finding and refining those special images to the exclusion of shots of lesser towns and events. In that fashion, the Tony Stone Images collection garnered mainly high-priced RM double-page spreads and magazine covers, called "hero shots," rather than small incidental placements. But this was before print publications felt the impact of the Internet. Today, users have access to millions of microstock images—ranging from dramatic shots to street scenes from the most remote areas of the world—taken by microstock photographers based in more than two hundred countries.

To maximize downloads of your travel images, capture the six to twelve "hero images" for your location, but don't neglect the rest. Document the location as if you were doing an in-depth story on its people, history, and attractions. Stop by a travel agency or go on travel websites to find ideas for secondary images, such as of regional cuisine, pottery, or local art. Other shots that round out coverage are museum exteriors, close-ups of goods offered in outdoor stalls or flea markets, and images of day-to-day life. The steps involved in planning a destination shoot, whether at home or away, are summed up with one word: "research"! Here are tips on getting the most out of your travel shoot.

Be sure to include dramatic "hero images" in your portfolio of a location, such as this shot of Beijing's National Stadium, nicknamed the Bird's Nest.

- **Locations.** Get a tourist's-eye view by taking a bus tour. You'll pass all the most important places and can usually get off and wander around on your own to plan your shoots for later. If you explore, you'll see a place in the grass worn down by the thousands of photographers who have gone before you, seeking to capture the "money shot." How can you take images that will stand out among the thousands of pictures of travel icons such as Golden Gate Bridge or the Acropolis? Stand where others have and then walk around until you find a less popular point of view; make it your own by shooting in the best available light.

- **People.** If your destination is known for fabulous beaches, posh hotels, award-winning golf courses, and beautiful weather, it will be difficult to get usable pictures without including at least some people. Your challenge in these situations is to find models. Depending on your level of schmoozing confidence, you may be able to talk your way into convincing the interesting couple in the hotel bar to model for you. Unless you are taking images for purely editorial usage, you will need model releases from anyone in your pictures, including the indigenous population. Model releases are available in

Images of popular destinations, such as this one of London's Palace of Westminster and Big Ben, never go out of style. Don't neglect shooting them because so many others have gone before you; tour companies always seek fresh takes on an old subject.

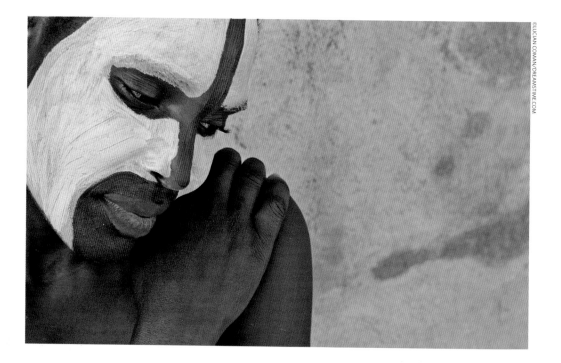

Photographer Lucian Coman lives in Botswana and takes advantage of his location to shoot images that others must travel thousands of miles to reach.

the native language of most countries visited by Western photographers, but not for extremely remote areas, where you may find you cannot communicate with your subjects. The solution is to position individuals so they are not recognizable, or to submit the images for editorial use only. Hotels can sometimes connect you with a driver to take you around and to help you communicate with your subjects. Thanks to the world of social networking, you might find someone in the microstock forums, or on Facebook or Twitter, who lives in the area and is willing to help.

- **Crafts and food.** Vacationers want to sample new dishes and buy arts and crafts. Local markets are prime spots to find both.
- **Holidays and events.** Are there significant holidays or events that are important to visitors? You'll want to know this before you arrive in your location. No one likes arriving the day *after* the biggest event of the year.
- **Weather.** You can't do anything about the weather, except plan to arrive when available records indicate the weather is normally suitable for your shot list. If it rains, photograph the rain.

Local goods and crafts found in outdoor markets add a splash of local color to brochures.

Tony Stone advises photographers to spend a day or more in a new city without a camera before deciding where and when to get the best shots. Of course, you might find yourself without a camera just as a once-in-a-lifetime shot unfolds in front of your eyes! So maybe keep the camera tucked away, just in case.

■ NATURE AND ANIMALS

There are millions of different species of animals, and some of the most popular microstock images are of scary, beautiful, or endangered ones. There are huge audiences for exceptional wildlife photography, with calendars and books featuring stunning images of endangered species, as well as colorful birds, lions, and bears, and the ever-popular shots of baby animals.

Close-ups of terrifying spiders, such as the tarantula or wolf spider, will get multiple downloads, as will those of charging rhinos, roaring lions, open-mouthed sharks, and running cheetahs. People are fascinated by fearsome animals, and this emotion is turned into admiration when used in ads. I call this category of photos the "snarlers and growlers."

The shark is a symbol of greed and danger. The more frightening the appearance of certain wild animals, the more likely the shot is to be downloaded.

©BRIAN HANSEN STOCK PHOTOGRAPHY/SHUTTERSTOCK

©CATHY KEIFER/SHUTTERSTOCK

A patient photographer caught this snowy owl in flight. Shots of airborne birds are difficult to capture without planning and perseverance.

In this image, a male wolf spider captures a blowfly. The microstock caption states the common names of the spider and fly, making the photo more useful. The Latin names would add even more valuable information.

Animals that display humanlike facial expressions or unusual behavior easily capture the imagination.

©F.MANN/SHUTTERSTOCK

Patience is a major requirement for photographing animals—they may rest for hours before suddenly springing into action, and you have to learn to anticipate their movements to get the best shots. Not long ago, a humpback whale was breeching in Puget Sound; people with cameras were lined up on the shoreline watching and taking photos . . . but no one in my area of the beach came home with a photo of anything more than a big splash in the water. If they had watched carefully before shooting, they would have seen that the whale spouted just before it leaped into the air, and that cue would have prepared them to press the shutter at the right moment. My favorite animal image is of a lioness and her cub from the book *Serengeti: Natural Order on the African Plain*, by Japanese photographer Mitsuaki Iwago. The photos were compiled during a year-and-a-half period, while Iwago lived in the Serengeti National Park in Tanzania and reportedly spent months watching the lions while stationed in a hidden blind that he built in the wild.

Maybe you think a trip to the zoo will provide an easier route to believable wild animal images? Not so fast. Zoo pictures are easy to spot even if you manage to shoot around fences and barriers because the background

©PIOTR SKUBISZ/SHUTTERSTOCK

Images of clean water and crisp, clear air are sought by businesses advertising the "green" philosophy behind their operations.

is usually a dead giveaway. A wild animal park is a better choice. Make sure to read the legal fine print on the back of the entry ticket so that you don't violate any of the park's photo regulations.

Whenever photographing animals, remember to emphasize the eyes. Animals, like humans, connect most effectively with the camera when they are looking directly at the lens. You are not likely to get close enough for a full portrait, so bring along the longest lens you have.

Images of nature are another popular theme, especially those conveying messages of "fresh," "pure," and "uncontaminated," which businesses use to advertise commitments to clean energy, recycling policies, and concern for the planet. Desirable images include waterfalls or lakes in pristine natural settings, sparkling mountain streams, and immaculate ocean beaches.

Horticultural encyclopedias license close-up images of native and cultivated plants. These images are not best sellers by any means, but if botany is your specialty, you can use your knowledge to make your images more valuable. The most important part of a plant identification photo is not the image itself so much as the correct common and Latin names in the keywords.

Here are more popular categories for nature and animal photos:
- Large mammals, such as the big cats, elephants, and herds of migrating African animals
- Deer, wolves, coyotes, moose, elk, and other species native to the United States
- Whales and sharks
- Colorful and popular birds, such as parrots
- Forests and trees, such as redwoods and sequoias, that typify a place
- Insects such as the female praying mantis, butterflies, and moths
- The life cycles of plants and animals
- Microscopic organisms, especially those in the news, such as the HIV and flu viruses or micrographs of cell division
- Seasonal landscapes of rural or unspoiled nature, especially autumnal trees, sparkling streams, snowy forests, vast meadows of wildflowers, and huge ocean waves
- Close-ups of leaves and other symbols of nature

©COOLR/SHUTTERSTOCK

Photos that symbolize Nature serve as iconic images for natural foods and organic businesses, and are used as effective backgrounds. Because such images are straightforward compositions, they often sell better than complex landscape photos.

■ AGRICULTURE

The demand for photos of farms and ranches has diminished during the past few decades as the number of family farms has fallen. Today's agricultural images lean toward idealized scenes of fields and farms, harvesting, equipment, and farm animals. Agricultural scenes are popular for calendars and as concept images to illustrate abundance and organic products. If you live close to a farming community, photograph agriculture in all seasons.

The "must get" images in this genre include:

- Large farming equipment, such as harvesters, combines, and modern tractors at work
- Herds of cattle and horses, dairy cattle being milked, pigs, and other farm animals
- Barns, which are iconic symbols of the American Midwest and are featured on cards and especially calendars. You must bring a fresh vision to this class of image because it has been reworked thousands of times.
- Vintage farm equipment and other items that evoke nostalgia for the family farm
- Fields of grain, corn, and other crops at all stages of growth, from seedlings to harvest and beyond
- Abandoned family farms
- Interiors of commercial greenhouses

©LAURENT RENAULT/SHUTTERSTOCK

Agricultural images, especially those that show large-scale operations such as these fields of lettuce, should emphasize the health and vigor of the plants.

An assortment of mini cakes works as a "crossover" image—it could be used as a food shot for an issue on desserts, as a warning to convey the dangers of sugar, or as a concept image to illustrate "variety."

▌*FOOD AND BEVERAGES*

I call the urge to photograph food when you don't have the requisite skills the "Steak Pizzaiola Effect." A photographer friend was given a small assignment by a Los Angeles newspaper for its food section. The paper provided a recipe for steak pizzaiola along with examples of the images they wanted. The photographer was to prepare the food and then shoot the resulting dish close up as well as with a couple enjoying the meal. Three times he cooked the meal; three times he shot it; three times it was rejected. He was an accomplished photographer and cook, but not a food photographer. What this unfortunate photographer needed was a food *stylist*. Food stylists know to put a squirt of dishwashing detergent into a cup of coffee so the resulting bubbles resemble those in a freshly poured cup, along with having a huge bag of other tricks. If you want to know how unappetizing food usually appears without the aid of styling techniques, snap your next few meals. It's rarely a pretty sight, even if you are dining in a four-star venue.

Food photography today has a more casual style than it once did, and the dish doesn't need to look perfect. Current magazines show cake crumbs on a plate along with the fork used to take the first bite. A casserole dish may have burned cheese on the sides of an otherwise appetizing lasagna.

Here are some tricks to help you add food and beverage photographs to your microstock portfolio:

- **Keep it simple.** Lighting a huge holiday meal displayed on a sumptuous dining-room table will present multiple challenges. If you want to experiment in order to learn, go ahead, because these are highly sought-after images. If all else fails, you can enjoy eating the props.
- **Avoid fatty and greasy food.** These are more difficult to light owing to light reflections off the oil. Stick with salads (with the dressing on the side) and colorful drinks. Use available light whenever you can.
- **Consider the plates.** If a close-up of food is an assignment in your future, think about the plates you'll be using. Use plain white dishes to contrast with the food (unless the food is white) or coordinate the color with that in the food. Patterned dishes and flatware will imprint a certain style to your shot, which you may not wish to impart.
- **Stay healthy.** A growing emphasis on healthy eating means you should include fresh vegetable dishes as well as nutritious fruits and dairy products in your food portfolio. Shoot raw ingredients before the cooking starts.
- **. . . Or indulge.** Photos of hamburgers, fries, and other fast food serve to illustrate what *not* to eat on a healthy diet.

©OLGA LYUBKINA/SHUTTERSTOCK

©ROHIT SETH/SHUTTERSTOCK

One of the few situations where tilting the camera produces an effective image is when it is used to photograph single plates of food.

Photographing a full-course holiday meal without the help of a great food stylist is a challenge, even for experienced food photographers.

©SERGEY PETERMAN/SHUTTERSTOCK

Clean shots of typical items are used on photo menu boards in small fast-food establishments. Larger chains usually have their images custom-produced.

- **Avoid brown.** Food color and consistency can turn a tantalizing dish into a photo of an unappetizing meal. Except for meat dishes and chocolate, brown is not a good choice of palette.
- **Convey stories.** To illustrate lifestyle themes using food, imagine stories that occur in the kitchen, such as kids baking cookies, a family preparing a meal in the kitchen, or a couple sharing kitchen duties.
- **Stay realistic.** A photo of a sinkful of dirty dishes says something about the messy nature of cooking, and so it's a shot I like. What I don't like are photos of cooks at work using obviously new pots and pans, with nothing on the kitchen counter. However, that doesn't mean you should include old, blackened pans. Also, be careful not to stage shots with empty pots on a cold stove.

If you want to want to be a full-time food photographer, find the best specialty photographer in your area and become an assistant. You'll learn that shooting a subject that simply sits still on a plate is almost as challenging as catching a basketball star's hoop shot. San Francisco food photographer Michael Lamotte specializes in ice cream, among other food items. He has three freezers in his studio, including a dipping freezer like they have in ice cream stores. He stated in an interview that for every twenty-five scoops of ice cream his food stylist makes, twenty are thrown away because they aren't perfect. Among other stratagems, he suggests cutting a carton of ice cream down the middle to find the place where the swirls of fudge or caramel are at their best.

◣ ENERGY AND THE ENVIRONMENT

Environmental issues dominate politics, government budgets, and new industries. Photos of solar panels, wind turbines, hybrid and electric cars, and recycling centers are a few of the visuals that are desirable for power/electricity/fuel articles, blogs, and advertising. Expand your chances of licensing these popular images by deepening your understanding of the subjects. Solar panels by themselves are rather uninteresting, so show their installation or manufacturing. Indicate the relative scale of wind turbines by placing a person in the image. Home-sized wind-powered devices are on the market and need photo documentation.

Recycling is a messy task and not photogenic. Wide-angle shots of

©EUTOCH/SHUTTERSTOCK

"Casual Friday" is the concept represented by this row of jackets. The jean jacket facing the opposite direction from the others could also imply anticipation of the weekend.

garbage dumps have a purpose, but you can also go for extreme close-ups that turn recycled goods into graphic statements. If you're photographing a hybrid car, for example, try to ensure that it is not the sole focus of the photo but an incidental prop in order to avoid trademark or trade-dress issues. (*Trade dress* refers to the instantly recognizable and trademarked shape of a product, such as that of the VW Bug.) New energy-saving devices are being developed all the time. Keep up-to-date with developments so you will be the first to upload the photos.

◼ *CONCEPT IMAGES*

A concept image is a photo that "says" something in addition to the noun or verb it is illustrating. Concepts are the adjectives, adverbs, and emotionally evocative words an image can support beyond its actual elements. For example, a photograph of a jogger running along a country road conveys messages of endurance, strength, or commitment. It could also say "fast," "energetic," or "exhausting" (to me!).

Concepts should be recognizable without hitting the viewer over the head. "Time" is a valuable theme, especially for time-saving products and "just in time" business solutions. "Wake-up time" is often illustrated by a photo of a sleepy person reaching for an alarm clock on a bedside table;

Opposites have an immediate emotional appeal, so a photo like this evokes many concepts, such as communication, polarity, and attraction.

thus, it was refreshing when photographer Jan Stromme nailed the concept in an entirely fresh way by photographing a bedside clock radio that had suffered a severe blow with a large object.

Keywords turn many images into concept photos. Most microstock companies discourage you from attaching multiple concept words to a photo, as it may result in confusing search results. By sticking to nouns and verbs, the search results will be more predictable, an important asset for the photo researcher. In reality, users search using nouns *and* concept words. You could lose sales by eliminating all concept keywords from your submissions or, alternatively, be blocked from sites for adding extraneous words. Take care to notice the keywording rules for each site because their requirements vary. My advice is to use the most obvious, such as "strength" for a photo of a body builder, but leave less obvious ones out of the mix. See also Chapter 10 for more on keywords.

Among the most commonly requested concept keywords are:
- Time. A clock with spinning hands illustrates time passing and is an old cinematic technique that photographers have adapted to the still image.
- Strength

- Peaceful
- Fresh
- Success (winning)
- Emotions such as love, joy, happiness, frustration, anger, and fear.
- Teamwork. Business teams are the obvious subjects for this concept, but also consider sports teams, teams of horses working together, flocks of birds, and images of other social animals such as ants.
- Holidays. Background images with themes of St. Patrick's Day or Valentine's Day emphasize the colors associated with the holiday. These images add seasonal flair to websites and are used for greeting cards.

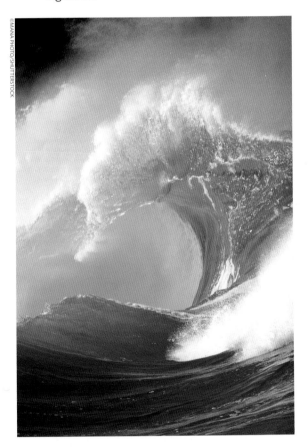

Concept keywords for this image could be "power," "strength," and "force."

A guard dog can symbolize the concepts of protection, anger, fear, and danger (*top*).

Images of social animals such as ants and bees serve as symbols for teamwork, as well as illustrating articles about the insects themselves (*above*).

▌ ARCHITECTURE AND INTERIORS

A wide range of image buyers use the interiors of professionally decorated homes and offices. A room with a gleaming hardwood floor may appeal to a company that rents floor buffers or one that installs flooring. A house-keeping service might use the same shot to promote its services.

Beate Chelette, owner of Photography Business Secrets, was one of the pioneers who brought photos of home interiors into mainstream stock collections with her company, Beateworks. According to her, images of beautiful contemporary, modern, or traditional living rooms have a broad array of applications. Paint companies license images to showcase various colors available; consumer electronics are dropped into a photo of a room; and advertisements for products that are virtually "invisible," such as security systems, heating, utilities, and air conditioning, are made more lively by employing interior shots. Banks use architectural images in advertisements to encourage home financing.

Residential exterior photos set the scene for real estate websites, gardening services, pest control companies, and roofing installers. There are as many uses for images of well-kept condos as there are for those showcasing mini-mansions and huge estates.

Traditional home interiors are more in demand than those with trendy furnishings because the latter may limit the image's appeal to a mass-market product.

©CHAD MCDERMOTT/SHUTTERSTOCK

Photograph residential exteriors during the late spring or summer when the landscape will be at its best. Photographer Jonathan Ross discovered a market for the location images he takes during the production of a business or lifestyle shoot. While photographing a dentist and his team, Ross also shoots scenes in the modern dental office without the models.

◗ SEASONAL

Calendar publishers depend heavily on seasonal photos to illustrate the months of the year. Periodicals and blogs feature images taken during different seasons to continually refresh their pages. Flyers for retail shops use seasonal landscapes as backgrounds to add flavor to monthly promotions.

Landscapes with fall colors leave no doubt as to the season, nor do snow scenes. Winter landscapes should evoke the beauty of the season by capturing falling snow or a fresh coat of snow on a rural scene. (Save the snowstorm photos for use by insurance companies.) Daffodils and crocuses are harbingers of spring, as are cherry blossoms.

A seasonal collection should also have representative images from the major holidays, including local and regional ones. Since the majority of microstock image buyers are from the United States, photos taken during American holiday festivities sell well. Ensure that photos of your national flag are found in your portfolio, too.

Andrushko has created an enhanced reality shot for the Fourth of July by compositing several firework images.

06

POPULAR THEMES WITH PEOPLE

At least half of the top ten consistently best-selling microstock images contain people. These images can be difficult to shoot, because often someone's eyes are shut or the smile looks more like a grimace. Even taking photographs of experienced models can result in poorly selling photos. And yet most buyers are looking for photos of people to use in promotional websites, ads, brochures, or publications: a classic case of supply and demand. Businesspeople and meeting situations are an important genre as buyers of corporate images are among the largest group of microstock users. Images of families are popular with financial institutions and vacation and travel companies. Individual portraits can stand in as spokespeople for products or services. These images can be among the most difficult and expensive to produce, but if you can successfully create them, you will be pleased with the payoffs. See Chapter 8 for specific help on casting and working with models.

▌ *BUSINESS AND PROFESSIONS*

Business images fall into three general categories: white-collar workers and teams, small business owners/customers, and professionals such as attorneys and health care employees. One popular type of image in this genre is the "spokesperson," or "testimonial," photo. This is a portrait or full-body shot of a single person who appears to be speaking to the viewer. An example would be a photo of a businesswoman thoughtfully looking out an office window, used in an ad for an accounting program, with the copy reading, "Our systems ensure accuracy and take away concerns about filing deadlines." It's especially important to leave blank space for copy in testimonial images. You will have more downloads of images that leave space around the model than from very tightly cropped portraits.

Another popular type of image is one that conveys "teamwork," a major keyword search for business images, by showing several people (at least three) working together. I have one personal no-no for this genre, and that is having one person in a group pointing at a computer screen. This shot nearly always looks posed. To avoid this impression, display something interesting on the computer so that when the models are engaged in looking at the screen, the result will appear more authentic.

In business situations, models should represent ethnic diversity and the appropriate age for the position. I frequently hear from image buyers that they have difficulty finding images that show a mix of people from

This shot has most of the ingredients of a best-selling business photo. There is a younger man in front, while the traditional CEO-type model is a step behind. The team is walking toward the camera as if to come forward to solve problems for their clients. The location is a believable corporate office, and there is a range of ages in the models. The only missing element is ethnic diversity.

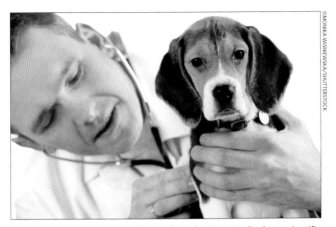

©MONIKA WISNIEWSKA/SHUTTERSTOCK

Ask an expert to be your adviser when shooting medical or scientific photos. Make certain that the procedures or equipment you are photographing are being used in a realistic and professionally correct manner.

different ethnic backgrounds. Naturally, in some countries, images of a particular type of person that dominates that country's demographics are more important. In a country such as the United States, however, where the population is made up of diverse groups of people, a mix of races among the models in a business situation will be downloaded more often than a shot consisting of all Caucasian models.

A typical business production is set in a corporate-style office with a contemporary look. Soften the scene with flowers on a desk. Add variety with potted plants, or bring along framed copies of your family photos to use as desktop props. Increasingly, requests are also appearing for business photos showing telecommuting and home offices. To prevent home office photos from being confused with recreational or personal computer use, cover the desk with business gear props such as files, and include a computer bag and an office-style desk and chair.

The best seller in the doctor/nurse category remains a single doctor in a lab coat with a stethoscope around his neck, isolated against a white background. Next in popularity is a medical team shot that includes, at a minimum, a doctor and nurses. A simple shot much in demand is of a pharmaceutical salesperson meeting with a doctor in his/her office. The choice of models is critical in medical shots: Doctors, dentists, and nurses should be age appropriate, wearing little makeup or jewelry. Photos of overtly sexy nurses are passé.

A woman in a fertility clinic is adding sperm to egg cells. The photographer included a detailed caption that gives users confidence that they're identifying the procedure accurately, yet the photo is generic enough to be of a professional in any of the health and biological sciences.

Courtroom shots can be challenging, as finding a courtroom location could be difficult. Showing a full jury trial requires at least fifteen models. The most important courtroom shot using a single model is of a judge handing down a ruling. You can cover the attorney genre by using a backdrop of standard law library books (all law offices have these tan and red books) and a serious-looking model of either sex in a business suit.

You'll save time and money if you storyboard your shots in advance (see page 153). When you have planned a daylong production, ask one or two models to arrive early, when the sun is still low in the sky, and shoot outdoors, on a sidewalk, bus or train stop, or in a park to show a walk to or from work. (Don't forget those permits.) Give your models a short break while you set up your props in a rented office, and then shoot the models one at a time and together for a couple of hours. Arrange to have two more models arrive just before a lunch break. Shoot with all four models in a conference room, office, hallway, and break room until midafternoon. Let the first two models go and photograph the remaining two, concluding with them outdoors at the end of the day, when the light is optimal. All of this sounds simple, but without at least one assistant and one person acting as a stylist and all-around gofer, you will have a very difficult task completing the shoot. There should be at least two wardrobe changes per model.

There are also simpler ways to capture business-themed images. You could ask a model wearing business-casual clothes and carrying a laptop bag (fewer and fewer people carry briefcases) to simply walk down the sidewalk in a commercial section of town. Shooting a person talking on a cell phone has been so overdone that doing it again is beyond boring; even so, new phones come out almost every day, making thousands of business shots obsolete all too quickly. You can try to stay ahead of the curve by shooting the new phone models as soon as they hit the market; if you are lucky, your images will get sufficient downloads by the time the next new gadget arrives.

Here are a few more tips for shooting business-themed images:

- **Show a range of ages and a mix of women and men.** Don't stereotype your subjects: CEOs aren't all men with gray hair, business teams aren't always made up of beautiful people in their twenties, and administrative assistants aren't always women.

©GABRIEL MOISA/SHUTTERSTOCK

As the workforce changes world-wide, more buyers request stock photos featuring women as business leaders.

- **Stretch beyond suits.** Real people at work don't always wear business suits. Casual Friday has become casual every day, especially in the technology sector and among younger business executives. Have your models roll up their sleeves and hang their jackets over the backs of their chairs, for example.
- **Avoid glamour shots.** Makeup for business shoots should be subdued unless you are creating a concept shot of the office flirt or illustrating office romance—then you can exaggerate the make-up factor to drive home your point. Apply the same conservative approach to accessories and clothing.

Small businesses contribute more to most national economies than huge corporations. Use the traits and tasks of successful small business owners to create a shot list.

Here are some production ideas:
- **Effective leadership.** People in positions of leadership take many forms. Show the head chef in a restaurant, the owner of a framing shop behind the counter, or the manager of a plumbing business, as well as the more traditional casually dressed person leading a small meeting.
- **Teamwork.** Photograph a chef with his/her crew or a startup company in a garage.

- **Good vendor relations.** Imagine situations in which a salesperson is selling a business owner a needed product.
- **Financing.** One of the few times individuals visit banks in person is to arrange for loans for a small business. Depicting a person sitting across the desk in a nondescript business environment conveys this scenario.
- **Customers.** Include customers in shots of retail stores, restaurants, auto repair shops, and grocery stores. Images of couples eating in small, intimate restaurants are useful on a neighborhood diner's website. ("Couple dining" is a category often downloaded for travel brochures, too.) A shot of an individual building a backyard deck not only showcases one of the most common do-it-yourself home-improvement projects, but it offers an image that is useful to all the small businesses that supply nails, wood, deck stain, railings, and furniture.

▌ MANUFACTURING AND INDUSTRIAL

Access to manufacturing plants has become difficult, as security has become a top priority. Instead, get permission to photograph workers on a small construction site or landscaping crew. The owners of small companies are more likely to be approachable than a large aircraft or auto manufacturer. In the case of the local machine shop, offer to trade your photographs for access to the plant and the workers. Document the manufacturing process while creating photos that are graphically interesting. Look for patterns in the machinery and colorful processes. The employees should be actively engaged in their tasks.

▌ LIFESTYLE

The most overused and misunderstood word in the stock photo vocabulary is "lifestyle." Initially, the term was used to refer to photos of "alternative" lifestyles. Over time, the meaning has morphed and now represents most images of couples (both straight and gay), families, and friends interacting (but not at work). The category includes families, teens, couples, people with their pets, older individuals, and some travel images featuring people. Here is a breakdown of each subset.

©OLLY/SHUTTERSTOCK

Family Images

Next to business-themed photos, the family category is the most sought after when it comes to stock photos of people. Images of happy families are used in articles, websites, and advertisements for the health care and insurance businesses, for tour- and travel-related materials, grocery circulars, and a myriad of other uses. The standard image is of an idealized family with two young children and a pet, usually a dog. This image has been a favorite for decades, and thousands of photos that meet the description are available. Even so, a new image in the genre can still rise to the top and stay there for a long time.

Butcher, baker, candlestick maker . . . it's the everyday worker who retail shops, insurance salespeople, auto dealers, and banks want to reach with their ads.

©HAWAYA/SHUTTERSTOCK

©CHRISTIAN LAGEREK/SHUTTERSTOCK

Images that show the relationship between a pet and its owner are considered "lifestyle" photos. This one is especially attractive because the cat's personality is revealed in its eyes and the position of its paw on the owner's shoulder.

The challenge of showing a gritty job in a beautifully lit image has been accomplished in this photo by Christian Lagerek.

The best locations/sets for family shoots change to reflect social trends. After 9/11, demand for vacation travel images shifted from an emphasis on photos of romantic couples to more family images. The family dinner, which had fallen by the wayside in the busy two-job families of the 1990s, returned with the recession of 2008, when economic woes forced families to spend more time at home, eating in. Family dinners are now back on the "most wanted" lists.

A backyard is a natural setting for large, multigenerational gatherings. Barbecues and swimming parties are good bets, but you may want to get Grandpa in the water before you photograph him in his swimsuit. Get a cheap underwater camera and take photos of kids diving or swimming toward you. If you like the shots, you can invest in underwater housing for your more expensive camera.

Highlight the ideal states of happiness, togetherness, satisfaction, and affection. Once you have taken family group shots, ask the models to interact one-on-one. Shoot with the camera off the tripod. You want a casual composition, almost like a snapshot. Move around and between the models as you photograph to add realism; it's the interaction between family and friends that you are looking for.

©IOFOTO/SHUTTERSTOCK

An image of a father and child could represent the family life of a single parent.

Simulate family vacations by taking models to a beach or lake. Photograph a family group packing the car with suitcases and props such as snowboards or beach balls to indicate different destinations. Show one family member using a point-and-shoot camera to take souvenir photos.

Infants and Babies

Infants and babies are fragile, helpless, and timelessly cute. Add a mother to the shot and you have rendered a universal likeness of caring and love. It was thought for a long time that adding blue tones to stock photos, especially of a mother and child, would add a subliminal emotional message of caring, but overly romanticized images of pregnancy and early motherhood shot with shimmering, translucent window coverings and tones of blue and soft light have become hackneyed. Modern moms look best in contemporary colors and styles.

You may have the idea to illustrate the dangers of very young babies sleeping with stuffed animals by showing a few of them in a crib, but the

Analyzing a Best Seller

Photographer Ron Chapple created this almost perfect family portrait in 2008. As of this writing, it and a very similar shot, also shown here, topped the list of best-selling images on several sites. Here are some reasons why both became best sellers:

- **Location:** The location is nonspecific and shows a top vacation spot: the beach. In fact, it could be anywhere that has sandy beaches.
- **Seasonality:** As implied by the models' outfits, the photo could have been taken in spring, summer, or early fall, adding to its versatility.
- **Wardrobe:** The models' clothing complements the colors in the scene. Because there are blues, pinks, tan, and yellows in the palette, almost any color typeface could coordinate with the image. The shirts lack logos and the fabrics are solid colors.
- **Casting:** The models form the perfect, idealized family, and yet they aren't so beautiful as to look inauthentic. Their pose is relaxed and happy, just the way we all imagine the perfect family vacation. The image depicts the vacation to which every family aspires.
- **Concepts:** Happiness, togetherness, relaxation, family, and fun are all represented here.
- **Composition:** The models are posed off-center to leave lots of space for type. The background is clean and simple. The makeup of a traditional, conservative family is indicated by putting the father at the top of the photo.

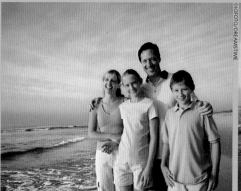 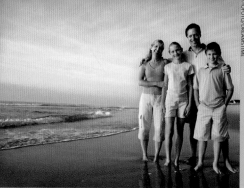

If an image is a great stock photo, even a cropped or almost identical version of it can make it into the higher ranks.

most downloaded images won't show toys for that very reason. Many characters portrayed on toys are trademarked, which is another reason to leave them out of the picture.

Happy babies make the best subjects, but an infant with a face contorted in hysteria has its place too. All parents take photos of milestones in their babies' development; smart photographers do the same. These include first teeth, crawling, and, most importantly, first steps.

Children

When photographing younger kids, don't work for more than thirty minutes without taking a break, and make sure to give them something to do or to eat then. Try to wrap up your shoot in half a day, even with older children, and always have a guardian present with you and the child. Check your local labor laws because some states require that you use children as models only for a limited time without a school representative or social worker present.

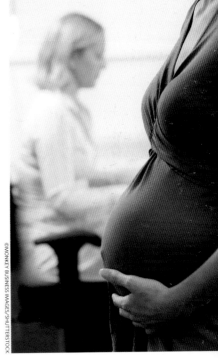

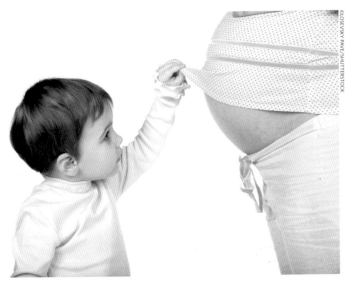

Overly romanticized images of pregnancy are passé. Today's images are more realistic, upbeat, even humorous, like this one (*above*).

Today's economic conditions leave many women little choice but to work up to the last days of their pregnancy, a stark reality well illustrated in this photo.

Although it can be tough to get little Jimmy to take out the trash in real life, in the stock photo world, some of the best photos show younger kids helping with yard duties, washing the car, or cooking with Mom or Dad.

Many of today's children don't spend a lot of time outside. They are much more likely to be inside playing video games or at a computer. Children as young as age four play computer games, so you should photograph them in these pursuits. And when they're not playing games, often the lives of children are programmed down to the last minute with activities, so make sure to photograph soccer practice, music lessons, chess games, and, of course, homework.

Two notes of caution: Children's clothing often carries trademarked characters, which should not be photographed. And always be sure to obtain parental permission before photographing children in public places; otherwise, parents may feel violated, and you risk being implicated in an

Preproduction research was essential to getting the details right in this shot.

The image of smiling teens has been downloaded twice as many times as the more somber one; it's usually more effective to sell products using positive emotions than negative ones.

offense you did not intend (and you will also need the releases in order for microstock houses to accept your photos).

Teens and Tweens

Many current photo collections fail to capture the degree to which technology permeates the lives of teenagers today. Young girls at sleepovers may still have pillow fights and gossip into the night, but they are just as likely to be texting their friends or gazing at a laptop.

Yuri Arcurs describes the work that went into prepping the skateboarder kids photo shown opposite. He wanted the photos to look like he had merely come upon some kids on the street, but in fact the set was extremely well-researched and carefully styled. None of the clothing or gear came from the models; even the backstage pass around the guy's neck was produced especially for the shoot. The blue and green color palette was carefully created. Research online and in a public skateboard park was essential to get small details right, such as the knee-protection gear falling down the boys' legs and the way they are carrying their skateboards.

Wardrobe should be very casual for teens (unless you want to photograph prom night). Teenagers and young-adult models look most authentic when they're wearing their own clothes, and they can quickly

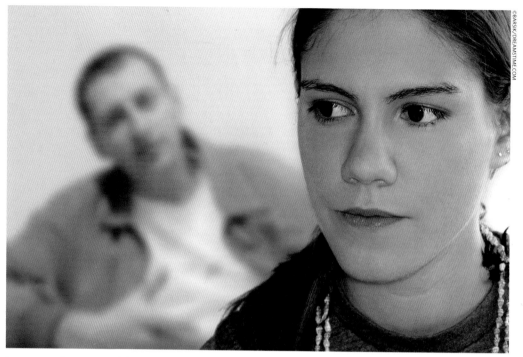

©BARSIK/DREAMSTIME.COM

Images are often requested that can evoke social issues and tensions that affect the lives of teenagers and their parents.

spot makeup, hair, and wardrobe that are not up-to-the-minute for their age-group. Commit to preproduction research so that you can dress teen models with attention to what is happening in *their* world. However, even though sayings and logos on clothes are as prevalent as the buttons on many shirts, keep T-shirts with statements out of the picture.

Couples

In the world of stock photography, couples are pictured primarily in romantic dining situations or resorts. But what if you don't have access to a particular restaurant or the funds to shoot at a resort? Ask yourself, "What do young couples buy as they set out on adult life?" Follow the money. They buy cars, electronics, condos, homes, engagement rings, moving services, furniture, clothes, dinnerware, and wedding gowns. You get the picture. For this reason, location may not be as important as the interaction between the two models. Good actors and models can simulate

emotion. If budget constraints keep you from hiring professionals, find an authentically happy couple. Their communication and body language will be easier for you to direct because they will already be comfortable with each other.

Pet Owners

People living with their pets consider them to be part of the family. Consumers spend millions of dollars a year on their pampered furry, finned, and feathered family members, and that translates into a demand for photography. Photos of people and pets are coveted by local veterinarians and national pet-supply companies for in-store displays, and animal rescue services need inexpensive images to use in their fund-raising efforts. The most important aspect to show is an emotional interaction between the animal and the pet owner. Close-ups accomplish this better than long, cluttered images where the interaction is not easily deciphered.

▌ HEALTH AND BEAUTY

Generally speaking, photos of scantily dressed, beautiful women are among the top downloads on all microstock sites. Those images showing a model getting a massage or facial serve the market for spa owners

©AVAVA/SHUTTERSTOCK

The most common pets in the United States are dogs, so it follows that canine photos will have more downloads. These creatures are also usually a lot easier to direct than those pesky, independent cats! An image of owners feeding and caring for their pets is a good production suggestion.

©OLLY/SHUTTERSTOCK

The model's body language and the look on her face say pure relaxation.

to promote their services. Spa vacation packages are available worldwide, and thousands of neighborhood hair and nail salons offer massage, facials, and other beauty treatments. Spas and manufacturers offer products including bathing salts, massage oil, and scented candles that use stock images, and spas offer illustrated menus of their services on their Web pages.

Search for "cucumber facial spa" on any site, whether it be RM, RF, or microstock, and you will find hundreds of similar images of women with colorful mud on their faces, their eyes hidden beneath slices of cucumber. Why is this image so popular? Because it's graphically interesting, colorful, and conveys the messages "rejuvenation," "healthy," "restful," and "relaxation." This image has been shot to death, however, so if you want to create a new take on it, visit a few spas and interview them about novel services. Go on the Internet and search spa services and vacations. The tone and colors are soft, tending toward pale greens and yellows. Try to create new images for the spa market that are graphically compelling and send the same messages—but without the cucumbers!

The grooming rituals we do in our own homes are popular as well, so photograph men shaving, children and adults brushing their teeth, and don't forget flossing. Other possible ideas for the health and beauty markets include models applying makeup or getting a haircut. A boy visiting

the barber for the first time often generates interesting facial expressions in both parties. Health topics should include walking and swimming, considered the best form of exercise for those over fifty. Add models of all ages doing yoga or meditating to top off a collection of health and beauty images.

In the middle of the twentieth century, before *Playboy Magazine*, photos of erotic nudes were displayed in magazines devoted to "health" and "nudism." Today's microstock sites confine images that are overtly and graphically erotic to a segregated area of the site, allowing the user to block their display in all search results, if desired. Even though the most-read of the hundreds of blog entries I wrote for Dreamstime was called "Sexy" (when last I looked, it had been opened hundreds of thousands of times), erotic photos are more often perused than downloaded. Searching on "sexy woman" with the filter off on Dreamstime reveals that the first erotic image shows up pages into a search that is sorted by top downloads.

That said, there is a market, so here are a few tips for shooting sexy photos:
- Make certain the models are of legal age. Because the age of consent varies by geographic location, be up-to-date on the laws in your shooting location.
- Since nudes are often shot barefoot (which brings to mind Randy Newman singing "Leave your hat on, baby"), take a look at the soles of the model's feet to make certain they aren't dirty.
- If you don't know the difference between what is an acceptable nude and one that you must mark for the restricted parts of a site, do some research by searching for "sexy nude woman (or man)" with the filter on and then off and compare the results.
- Limit full frontal nudes and totally nude models to the restricted sections of the microstock sites.

▌ GARDENING AND AGRICULTURE

Flowers are among the most photographed of all subjects and therefore are the least likely to make it past reviewers. Microstock sites state they don't want photos of flowers, yet outstanding shots of blossoms still can and will be accepted. Large botanical prints are popular with decorators as wall décor; close-ups of flowers and plants are used in cosmetic packaging,

©LORRAINE SWANSON/SHUTTERSTOCK

This photo could support many captions and messages, such as in an article on the value of wheat in the diet or the use of fertilizers. It is left to the caption or text to convey whether the farmer is disappointed or pleased by the quality of his crop.

garden center displays, and for resort and spa brochures. Blooms are also symbols of the seasons: Easter cards and messages often feature lilies, and the poinsettia is almost as universal as Santa Claus on holiday cards.

Gardening is big business, and not only for nurseries. Check out the number of products for sale at your local garden center: These include hats and gloves, shovels and clippers, soil amendments and seeds, plant starters, and deer repellent. Wherever thousands of products are sold, there are an equal number of ads, websites, and printed materials needing images.

Here are the scenes most in demand:
- People working in a garden (Don't make the mistake of keeping your models completely clean; nothing looks more staged than a gardener in clean boots.)
- People harvesting vegetables and picking flowers
- A farmer tending displays of organic vegetables at an outdoor market
- A person weeding with hand or power tools
- A homeowner mowing the grass
- A person relaxing in the garden while reading a book or in a hammock
- Children planting seeds or tending a young garden
- Neighbors working in a community garden
- Home canning preparation

Key shots involving people and agriculture:
- Farm kids with their animals
- Farm workers
- A farmer as a spokesperson
- Farm family
- Rancher herding cattle
- Dairy farmer overseeing milking operations

▌ *SPORTS*

Getting the best recreational sports photographs requires the same degree of patience and perseverance that a wildlife photographer must possess. The sports photographer must anticipate action in order to freeze the best tennis serve or golf shot. More commonly, sports photos with models will be staged, and the challenge is to make them look real.

A portfolio of recreational sports photos needs action shots, and to get the best ones you should be familiar with the sport. Remember the adage: "Shoot what you know." You may think your friend the golfer is

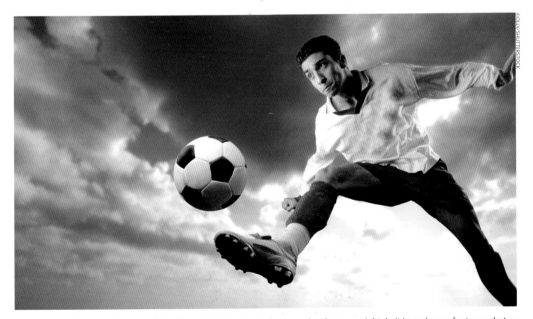

Professional players won't sign model releases, but amateurs playing on local teams might do it in exchange for team photos.

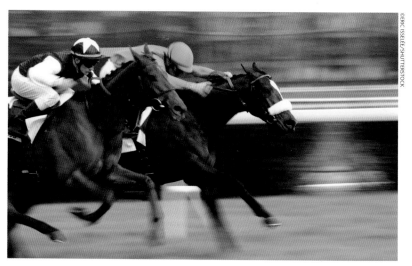

©ERIC ISSELEE/SHUTTERSTOCK

Photos of recreational sports players have an advantage over those of professional teams, players, or riders because model releases are available. If you wish to submit images of horse racing for commercial use, change the jockeys' riding colors in Photoshop or other photo editing software, since the colors identify the horse's owner.

very skilled; only when your photos don't get chosen do you realize that his swing is that of an amateur. For dangerous sports such as snowboarding and scuba, be experienced enough to keep up with your models. You need to anticipate the best shots, or you'll find yourself watching on the sidelines as the snowboarder sails off the drop while your camera remains untouched. A model who is proficient in a sport should already own most of the equipment you will need as props. If not, try to find rentals that are in good condition and not too beat up. If the sport draws a crowd, insert a background crowd to add a realistic touch to the image . . . but only if the result is believable.

Leisure sports serve as metaphors for challenge, endurance, and strength. A classic shot shows a climber at the top of a mountain at sunset. It's the grit and grime of a muddy mountain bike ride or the sweat of a long-distance runner that will add authenticity to your images. Use a squirt bottle filled with a mixture of water and glycerin to apply to your model in order to create the look of sweat on skin.

◀ CONCEPT IMAGES WITH PEOPLE

Using models to illustrate concepts is an effective way to avoid the obvious. More complex shots and composite images are apt to be used in high-end print rather than online because their subtleties are more

difficult to see at the thumbnail size, and getting the full value of the concept could require viewing them in a larger format. These are images that find a niche in half- or full-page ads in magazines, used editorially as well as for large newspaper ads.

Some concept images with people have been overdone, for example, a team of businessmen at the starting line of a race, models in business suits climbing a ladder, or a businessman or woman in boxing gloves. These hit-'em-over-the-head-with-the-idea images have been copied so many times they have become stale, in addition to not being all that interesting to begin with. (I confess to having been the lead on a team that created a photo of a businessman wearing red boxing gloves, but that was more than a decade ago, and I'm not certain it was a good idea even then.)

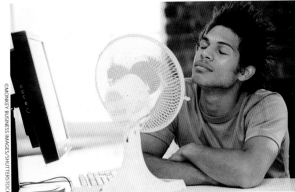

A concept image that delivers multiple messages is bound to find many buyers. The diner here could be viewed as hungry or greedy. He could be living in an era of abundance or be binging on an unhealthy diet. The photo could be used to tell about the success of the beef industry or about additives in meat.

How do you show the concept of hot weather, which is felt more than experienced visually? In this photo, the model's hair being blown by the fan and the look of pleasure on his face convey the reality that it is hot in the room.

SPECIALTY MARKETS
ADVERTISING, RETAIL, NEWS, AND EDUCATION

Many buyers of stock photography produce print and electronic media for specialty retail sales, educational, news, religious, and advertising markets. Each specialty prefers certain subjects and styles of photographs. For instance, the retail market uses photos in calendars and other products sold directly to the consumer. Rarely do these publishers download photos of people; instead, they prefer cute dogs or cats or majestic wild animals and scenic landscapes. Textbook publishers often choose photos of students of all ages and with a wide diversity of ethnicities. Churches and religious organizations often select images of a spiritual subject, as well as beautiful and serene landscapes. It's wise to recognize and familiarize yourself with these different markets while attempting to create images that apply to more than one area (known as "crossover images"). For example, a photo of a physician examining a patient could be used in a magazine article about the importance of annual physical examinations as well as in an online ad for cold medicine.

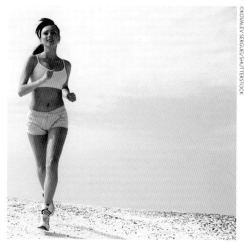

©KOVALEV SERGUEI/SHUTTERSTOCK

This photo of a young, casually dressed woman running in a nondescript location is a perfect crossover image. The composition leaves negative space on the right for the lead paragraphs of an article or for placement of product and advertising copy.

▌ ADVERTISING AND PROMOTION

Stock photos that designers and art directors choose for advertising, whether in print or electronic media, have slightly different visual criteria and very different legal requirements from editorial and news photos. The legal departments of ad agencies require that all people shown in photos they use have signed model releases. Unless the images are designed for use in the editorial sections of a microstock site, all reputable microstock companies will reject images that aren't submitted with model releases. When a photojournalist takes a photo specifically to illustrate a newspaper or magazine news article, however, he or she is not required to obtain a model release because the U.S. Constitution's First Amendment ensures freedom of the press to cover newsworthy events without the restrictions of privacy laws. Otherwise, it would be impossible to illustrate articles about war, politics, and a myriad of other social issues.

The formats of most successful images that advertisers select generally have negative space (an empty area in the image) to allow for type or product placement. This format is also preferred for use on magazine covers or as full-page photos illustrating feature articles. Shots that offer the user a blank space in which to enter his/her own message are among the best sellers. Examples are photos of a laptop computer or a TV with a blank screen isolated against a white background, which allows the end user to drop another photo onto the screen that displays the message.

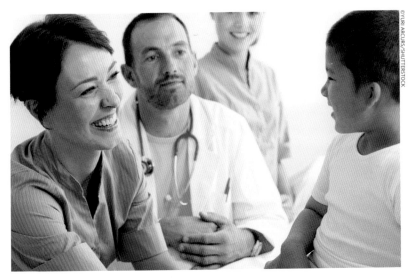

©YURI ARCURS/SHUTTERSTOCK

The models in this photo are "real"—pleasant in appearance but not overly idealized. The image breaks a few rules of ad shots by dint of its close cropping and lack of negative space, but it could be successfully run full frame.

Photos of billboards where the actual art has been replaced with white space serve the same purpose.

I often hear art buyers and photo editors declare that they want "real- looking" models in stock photos. What they actually mean is that they don't want models with artificial facial expressions who look obviously posed. The people in your images should be appealing but not high-fashion—unless your goal is to sell them for use with beauty products, for which idealized good looks are the norm.

If your photos include people, arm yourself with blank model releases before you go on a shoot. Don't even consider taking photos of people for anything but news uses without a model release. (For more about model releases, see Chapter 12.)

◤ RETAIL

Thousands of images are licensed for use on greeting cards, calendars, postcards, and posters, and as prints for office or home décor that are sold in retail stores and online. The greeting-card business is one of the most important of these markets. It is geared primarily toward vertical-format images (though squares and horizontals are just as important for the e-card business), a format in which it's particularly important that there

always be blank space to accommodate the text of the greeting. Think about creating crossover images that are useful as cards as well as for promotions and advertising. Using a Christmas theme as an example, let's examine how a winter holiday photo can become sought after in several markets.

Greeting Cards, Calendars, and Book Covers

Images that are not overtly religious have a broader base of users for Christmas cards. Here, the focus is on snow scenes, wreaths, and humorous takes on holiday icons. A popular image is that of a cozy cabin in a snowy forest with a decorated Christmas tree in the yard. A successful crossover image would be similar, but without the Christmas tree. The solitary cabin, with a warm glow coming from the windows, conveys a cozy feeling that can illustrate a variety of topics and themes beyond Christmas, such as an inexpensive holiday vacation away from the crowds. An advertiser might want to combine it with copy about the effectiveness of a furnace or the advantages of snow tires, or to promote other seasonal offerings.

Amusing animals are always in demand by greeting-card publishers.

©ANNETTE/SHUTTERSTOCK

A shot of a cabin in the snow requires a special location setup that could be costly, which is one reason these shots are so hard to come by. Fortunately, it's just one possibility out of thousands for a holiday theme. You'll see many greeting cards using close-up images of holiday icons. This means you can shoot something closer to home—a macro view of an ornament or an exterior of a snowman in your backyard. If you live in the South, take advantage of a nontraditional Christmas environment to compose an image with holiday props on the sand or by a pool. Believe it or not, the Christmas image that has outsold all others (that I'm aware of) is surprisingly simple: a stylized plastic snowflake isolated against a white background. No need to rent a cabin in the woods for that!

Photos of flowers are among the most sought after for general-interest applications and are used on holiday, birthday, sympathy, and wedding cards. Since they are a universal symbol of spring and evoke freshness and beauty, artistic floral images also make attractive wall décor. A cautionary note: Flowers are the most photographed of all nature subjects, so many microstock collections are highly selective in their choices.

Calendar images are often horizontal in format and depict various landscapes. Other popular subjects for calendar publishers are sports,

©ADNRELS PIDJASS/SHUTTERSTOCK

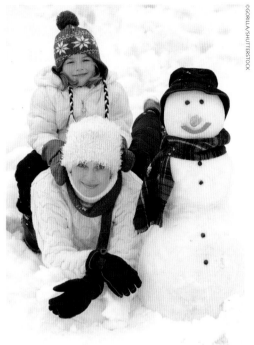

©GORILLA/SHUTTERSTOCK

Greeting cards can be created from simple images that don't require expensive or hard-to-find locations. This image allows space for a message and is interesting because it doesn't use the predictable red-and-green palette usually seen on Christmas cards.

hobbies, baby animals, seasonal scenes, horses, dogs, cats, antique cars, and occasionally, creative black-and-white images.

Interior Decoration

In the greeting-card business, color images may have an advantage over black-and-white photos, but nothing beats a lovely black-and-white photo as wall décor: This classic look adds sophistication to any decorating scheme. Publishers have recognized this and offer both professional and amateur, famous and unknown photographers a venue for publishing their black-and-white work. The market ranges from one-off signed prints offered by art galleries to single downloads for output to a buyer's personal printer. Unique works of art earn gallery representation, while more predictable subjects might glean multiple downloads from a commercial site. High-volume sales take the form of published and framed images sold in gift shops and online poster stores.

Styles in wall art shift along with trends in furniture and design, but certain subjects have staying power. Simple black-and-white landscapes

If the photographer had shot this snowman by itself while the models were taking a break, the resulting image would have been a good possibility for a secular Christmas card.

LUDMILA YILMAZ/SHUTTERSTOCK

Artistic renderings of floral arrangements are frequently seen framed or used on greeting cards. This photo of tulips has a painterly look that makes it appropriate for either sympathy or birthday card greetings.

©VICTORIA ALEXANDROVA/DREAMSTIME.COM

©EMIN KULIYEV/SHUTTERSTOCK

The simple, graphic style of this artful treatment of a woman's hand makes this image appropriate for a framed piece (right).

Prominent buildings, skylines, and bridges, such as this dramatic shot of New York City's Radio City Music Hall, are found on the walls of upscale hotels and other public venues (far right).

or photos of a dynamic and vibrant city at night remain popular. Photos of famous buildings and historic bridges are used as wall art in public spaces. Images of lighthouses and seashells adorn beach houses, and sailing enthusiasts hang artwork depicting boats. Restaurants choose images based on the type of cuisine: close-up food shots are popular on fast-food menus, whereas more upscale, ethnic eateries display landscapes from the region their cuisine hails from. One type of image that is not often chosen for these uses is portraits, as most people don't enjoy having images of strangers staring at them from the walls of their home or office unless they are relatives or historical figures.

As a popular wall treatment, interior decorators often use a series of images of the same general subject photographed in a similar style. The photographs are often simple botanicals or other natural objects isolated against a white background, and they may be framed together under one mat or in three or four separate frames. Keep this type of use and configuration in mind when you are shooting simple graphic elements, and create several variations that work as a series.

A nautilus shell isolated on white is typical of the photos used for adding atmosphere to homes at the beach.

Landscapes approached in a unique way, such as this intriguing photo of aspens behind a triangular rock in New Mexico, are of gallery quality.

◤ NEWS

If your greatest aspiration is to be a photojournalist, you are living in the best of times and the worst of times. Newspaper staffs are shrinking, and news magazines are thinner as advertisers flee to the Web. However, the bright spot is that publishers recognize that readers are going online for their news and are taking advantage of this shift to use more photography on their websites.

TV networks and local news shows, websites, and newspapers encourage their viewers to upload images of news and weather events. Some microstock companies, such as Dreamstime and Shutterstock, offer editorial licensing of photos from amateur and semipro photographers. News outlets have picked up breaking-news photos from Flickr, searching there in the minutes and hours after an important news event. For example, the U.K.-based *Telegraph* posted a story the day after the November 2008 Mumbai terrorist attacks commenting on the fact that most of the newsworthy images were coming from Indian citizens via Facebook feeds and from Flickr. The article stated: "Many mainstream media outlets, including

Because of security issues, access to political figures, especially in the case of the president, requires a press pass. A public event with seating close to the podium is the only other option. Failing that, you'll need a very long lens!

CNN, used video footage and photos sent in from people on the ground in Mumbai to illustrate their reports, and many television stations, radio stations and newspapers were also keeping a close eye on Twitter."

Major news topics include the following:

- **Sports.** Successful professional sports photography depends on access to the field and the players. This always presents a problem for nonprofessional photographers, and sometimes for good reason. It is assumed that amateurs are more likely to interfere with an event by not following accepted press behavior; for example, at the Tour de France bike race one year, an overly eager amateur photographer stepped into the road to snap an image of a biker, not realizing he was stepping in front of another biker, who then crashed. If a professional sports photographer acts inappropriately by getting in the way of an event, his or her press credentials will be yanked and he

Most news photos have a short life span, and their popularity falls off after a few weeks. This image of riot police could be used in an article about police gear, but since the photographer has not given specific information about "who, what, where, when, and why" the photo was taken, its editorial use is limited (*above*).

Although dropping out the background in this image would diminish the visual chaos and make it a better photo, changing an editorial image is not acceptable. To ensure accuracy, news-related images may not be altered, even when doing so would improve the composition (*left*).

or she will be out of business. Press passes to professional sporting events can be difficult to come by because the promoter or franchise holders may have an exclusive deal with a photo agency that limits freelance access.

- **Political and film celebrities.** Music, film, and political personalities have their favorite photographers, and the paparazzi do a good job of catching celebrities off guard. If you are so lucky as to come upon a famous person misbehaving, remember that yours is a "news" photo, and as such cannot be licensed to promote a product.

- **Disasters, such as fire, flood, and extreme weather.** It may be very tempting to photograph extreme events as they unfold, but such disaster photos can be hazardous in the making, especially during storms. So stay indoors, and remain out of harm's way in dangerous weather unless you know how to handle yourself. No shot is worth dying for.

- **Serious accidents, crime, and demonstrations.** If you happen upon these sorts of dramatic incidents while your camera is handy, you may capture a newsworthy image, but you need to exercise caution. Taking these sorts of shots is a good way to end up in jail if your actions interfere with a police investigation or if you stray beyond

Newsworthy photos capture the event and the people involved while creating interesting visuals. Technical quality is less important for illustrating the news than it is for commercial images.

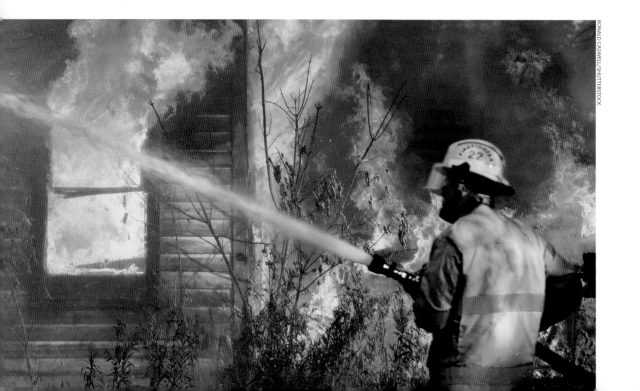

Backstage concert passes are usually reserved for a band's preferred photographers, but don't worry—on microstock sites, a generic crowd photo such as this one will outsell a close-up of the band.

police lines. If the police tell you to leave, do so. Even members of the working press with good credentials sometimes get arrested if they are trying to present a story to which someone in authority objects. Leave the dangerous stuff to the full-time professional photojournalists, unless you're willing to risk losing your camera or worse consequences.

- **Social issues, such as teen pregnancy, homelessness, and drug use.** Take care when documenting social issues—the man standing outside a shuttered factory may appear idle, but he might not be, and if the photo is used with a caption about the unemployed, you could get in trouble for misrepresenting him.

While I can't solve the problem of how to obtain press credentials if you are not a working press photographer, I can offer the following suggestions:

- **Stay local.** If sports photography is your passion, practice your craft where you can get the closest. Contact the local high school or amateur soccer league and offer to trade images for access. Note that you will have to remove all logos and other identifiable team colors and insignia if you plan to use the images commercially, even if you have model releases.

- **Get the nosebleed seats.** Into music but can't get a backstage pass? Then go for the cheap seats. Some of the most downloaded concert images are wide shots of the venue that render the band unrecognizable.
- **Learn Photoshop or other photo-editing software.** A photographer without a press pass once asked me what to shoot at the Olympic bobsled races. I suggested he shoot the races and then blur the photos to conceal identifying marks, team logos, and faces. The cleaned-up images could then be distributed for commercial use. Make learning Photoshop (or similar post-processing software) a priority so you can manipulate your output for broader appeal.
- **Read the fine print.** Always read the small print on tickets to events, theme parks, museums, and other public venues because, more often than not, there will be a notice prohibiting photography. You might get away with snapping a few images, but beware of trying to license them, even with a Creative Commons copyright. The Monterey Bay Aquarium in California, for example, has a magnificent jellyfish display; who would expect jellyfish to be recognizable? They are not, but the display itself is, and so the entry ticket forbids photos.

Read all the fine print on any admission ticket to a public venue such as a zoo or amusement park. If taking photos is prohibited, refrain from licensing any images that feature recognizable aspects of that place.

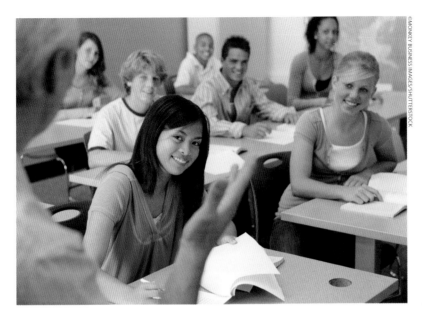

©MONKEY BUSINESS IMAGES/SHUTTERSTOCK

Most educational publishers require an ethnic mix in classroom scenes. The positive facial expressions on the students make this a potentially best-selling image.

- **Learn about and use the Shutterstock on the Red Carpet Program™.** Shutterstock will sponsor photographers seeking access to newsworthy events in order to greatly expand its coverage of such activities and celebrities while opening doors for photographers that would normally be closed. Photographers can use the online form at http://submit.shutterstock.com/redcarpet.pdf to engage the services of a Shutterstock rep to facilitate the acquisition of coveted press passes, whether for film premieres, award shows, concerts, or political rallies.

◼ EDUCATION

Images of students and instructors are used by educational publishers in textbooks, as well as to illustrate subjects in a curriculum. All educational publishers require accurate captions, and several additional requirements apply to photography for lower-grade-school textbooks. Even though usage in textbooks is considered editorial, many publishers require model releases. You must have a minor's release signed by the legal guardian. Check the IDs of older teens and youthful-looking adults to be certain they are old enough to legally sign a release.

Textbook publishers require a balanced ethnic mix among models. Young children have to be photographed using appropriate props and wardrobe, such as wearing bicycle helmets and carrying the see-through backpacks that many schools now require. Don't break any common-sense rules, such as showing a child in a dangerous situation, unless lack of safety is the point of the image and you have the situation completely under control during the shoot.

Many of the best photos for educational use are of students in school environments. I have been involved in several successful productions where the photographer arranged to take photos for stock as part of his fee for taking photos for a university's own publications. Use your connections to a teacher or other school representative to make the arrangements. If you need school kids in your shoot, it's best to use your own or your friends' children as subjects because getting the school to organize parental permission/releases will only complicate your production process. If you can't obtain permission to actually shoot in a school, try the local library as a possible location, or photograph children on a playground or carrying books as if they are walking to school. These images are always popular for back-to-school promotions and sales. Cautionary note: Don't show up unannounced at a playground and start photographing children without parental permission, for obvious reasons.

Photographs for the education market are best when they appear to show actual classrooms and students.

A still life of traditional educational symbols is often used for late-summer retail promotions and doesn't require models.

An apple sitting on the teacher's desk may be an age-old symbol of primary education, but the reality today is that technology is a significant aspect of education at all levels. Although school budgets often prohibit the constant updating of computers, your best bet is to take pictures inside a modern school where the latest technology is as familiar as the desks. The newer the equipment, the longer the photos will be useful. You can also get around the requirement to stay current by showing only a hint of a computer or other equipment in a classroom setting.

Home schooling is big business as school districts set up departments to assist parents in their home-schooling efforts and publishers print materials to the same end. To photograph this kind of alternative-learning environment, set up the home "classroom" in any kitchen or dining room. The situation will read better if you have several children of widely different grade levels all studying in the same residential environment.

Adult education is sometimes overlooked but is another important subject in the education genre. Photos with adults in learning centers at rows of computer stations could be featured on a website or brochure for a technical college or program. The students could be depicted as studying almost anything if the screens are kept out of view. Show a wide range of ages, as adult education serves the needs of young adults through retirees.

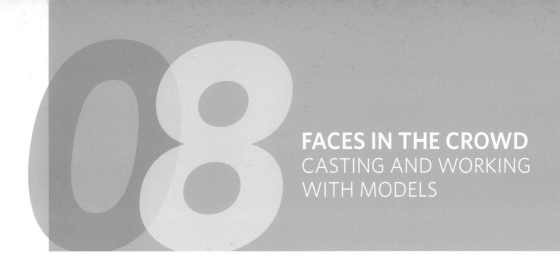

08

FACES IN THE CROWD
CASTING AND WORKING WITH MODELS

The question I am asked most often by aspiring photographers is how to work with models. The first thing I mention is that the initial challenge is finding people willing to work with you. You probably don't want to spend money on expensive professional models while you're still learning the basics, so my advice is to persuade your friends and family to let you take their photos in exchange for prints. As you learn by reviewing your images and comparing them with the most downloaded images on microstock sites, you will refine your composition and lighting techniques. You'll also gain valuable experience in directing people and a growing confidence about approaching potential models you meet socially or at work.

In a recent interview, respected longtime photographer Jay Maisel spoke about an experience with one of his workshop students who had brought in some amazing pictures at the outset of the class. When the class was completed, the student said to Jay, "I've gone swimming with sharks and alligators, crept up on grizzly bears, and risked everything for photos, but I've never been as profoundly uncomfortable and scared as when I took your class and you made me shoot people—thanks."

CASTING

Unless you are from a family of models or have a circle of willing friends, finding appropriate models can be one of the most difficult aspects of creating "people" photos. Whereas there is an abundance of images of young women in stock photo collections to choose from, areas that could use more coverage include photos of people over age fifty, authentic-looking businessmen and women, and models of various ethnicities. When you're casting a photo shoot, there are usually three categories of models available:

- **Nonprofessional models.** Friends, family, and work contacts may be the most appropriate people for inexpensive yet authentic

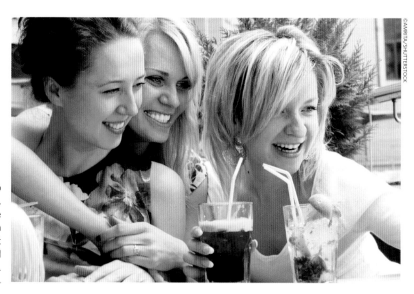

This photo of a small group of friends has a natural look. Although the models are attractive, they don't have a slick, high-fashion look that would come across as posed or unrealistic in a casual scene.

Professional models are skilled at relaxing in front of the camera, and their experience shows.

photographs. A terrific model for a small-business shoot might be the proprietor of a local business where a realistic interior location and props are in place. If you don't know the business owner personally, you can often connect through mutual friends or ask to speak to the owner the next time you are in a shop or restaurant as a customer. Offer to trade images for a few hours of shooting.

- **Professional and aspiring models.** Professional models are the most relaxed in front of the camera, and this attitude will help you get the shots you want. They should be adept at responding to direction. If you ask them to supply the wardrobe, they'll probably have a better feel for what will be appropriate than an amateur might. The downside to hiring experienced models through a professional agency is the high cost. Some models will respond directly to ads for stock photography shoots in order to supplement their income, charging fees that are less than half of what their agency demands. However, some modeling agencies won't let their models work on stock shoots because it would violate the exclusive arrangements they have with them; such agencies also seek to insulate their top models from overexposure in the marketplace's uncontrolled venues.

- **Actors.** I like working with unknown or amateur actors. Their training and personality enable them to quickly assume the role they are playing, and they are more genuine in front of the camera than some models. Actors also need lots of photos for headshots, and so a fair trade of their time for your photos can usually be arranged.

Not sure where to find models? Here are a few suggestions:

- **Advertise online.** Advertise on Craigslist.org, or other, more specific sites aimed at models, and offer to do test shoots. Be prepared to be overwhelmed with replies if you write a convincing ad. Minneapolis shooter Ed Bock has gotten great results using www.modelmayhem. com. He gets multiple responses from prospects who have reviewed the stock images on his website.

- **Street cast.** Stalking strangers—or "street casting," as it's called in the business—is a good way to find prospective models. Creative consultant Deanne Delbridge is always on the lookout for prospective models during her travels around San Francisco and had a business card designed to hand out specifically for this purpose. One side of the card reads, "I work with advertising photographers and would like to have one photograph you. These cards are only given to those individuals whose 'look,' character, or style I find interesting. There is no cost. Feel free to bring a friend/spouse/ parent with you." A photographer might replace the first sentence with "I am an advertising photographer and would like to photograph you for my portfolio." Delbridge notes that it is much easier for women to approach strangers, so she suggests male photographers bring a woman along to put potential models at ease. She finds that Saturday morning at the farmers' market is an excellent place to start. Bring a 5 x 8-inch horizontal "casting book" with a cover and eight to ten single images, one per page, to show samples of your work—or store some of your best images on your phone.

When you approach and/or use nonprofessional models, it's very important to make clear to them that you will have very little control over how the final images are used. Explain what stock photography is and offer details about some contexts and places in which the images might show up. Explain that there will be no further compensation from the use of the images. You can also show models the End User Licensing Agreement (EULA) from the microstock sites where you place your images, which usually prohibits the use of images in a defamatory or pornographic way. Reading the EULA may put some people's fears of exploitation at rest. EULAs are found on all microstock sites under Terms of License. The Shutterstock EULA is typical:

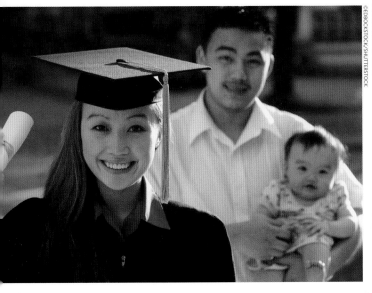

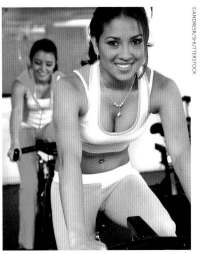

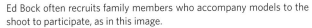

Ed Bock often recruits family members who accompany models to the shoot to participate, as in this image.

Seattle photographer Jonathan Ross recommends casting at gyms and health clubs, since people who work out tend to be in good shape and happy to have people look at them.

YOU MAY NOT
Use an image together with pornographic, defamatory, or otherwise unlawful or immoral content or in such a manner that it infringes upon any third party's trademark or intellectual property.

Model compensation can vary from a final print or copy of the photo to thousands of dollars in fees, depending on his or her experience and representation. Friends should be happy simply to receive a few prints or files. Nonprofessionals in the United States whom you street-cast or acquire through ads are usually paid with photos or up to $50 for half a day of work. Be prepared to pay more if you want a particular person. Professionals are paid the going rate their modeling agency charges, a relatively expensive fee based on the model's level of stardom and your geographical location. Some photographers in rights-managed businesses have made deals with models to pay them a percentage of the royalties received from stock sales. However, this creates an accounting nightmare and requires that you keep track of current addresses, so I advise against making such an arrangement.

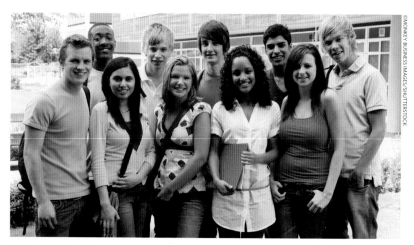

©MONKEY BUSINESS IMAGES/SHUTTERSTOCK

Monkey Business Images is a production company led by people with experience in the traditional royalty-free world. Their images display a deep knowledge of the requirements for ethnic diversity that many buyers share.

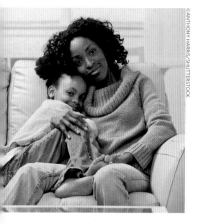

©ANTHONY HARRIS/SHUTTERSTOCK

Models with African ancestry, and members of all the major ethnic groups in your country, should be present in your portfolio.

When casting models, seek out diversity: An ethnic mix has been an important requirement for educational and business images for many years. There is currently demand for images of families of African American, Hispanic, Indian, and other ethnic backgrounds. For example, when the Obamas moved into the White House, an immediate upsurge took place in the use of black models appearing in advertisements, especially for insurance companies, health plans, and real estate. Currently, a popular look for stock models is that of the "world model": usually a woman between twenty and thirty years of age of mixed ethnicity. If she does not obviously belong to one ethnic group or another, she could represent any number of international backgrounds.

Diversity does not refer only to ethnicity and race. Plus-size models should be included in family or business shoots, as well as other lifestyle and spokesperson images, to offer variety. One of the most challenging demographics to represent is the over-fifty model. Consumers are smarter than they used to be, so they won't relate to images that are supposed to show older people but have models who are actually only in their forties with white hair. Instead, look for older models who smile easily and appear healthy and animated. Don't hide all the wrinkles, and don't use models who have had obvious cosmetic surgery. While you probably don't want

to submit photos of Uncle Elmer with the huge red nose, don't make the mistake of photographing only very attractive people either.

Models who resemble well-known public figures are often popular choices for advertisements. Our celebrity culture gives the public the feeling that they know and can trust a familiar face, a feeling that extends to models who look like them. Thus, advertisers often look for spokespeople who resemble celebrities to give testimonials for their products.

One common casting error is to use young or otherwise "inappropriate" models to stand in as physicians, attorneys, or other professionals. My favorite casting mistake was in a photo of a group of surgeons supposedly coming out of an operating room after a harrowing procedure. One of the "doctors" looked to be in his early twenties—and was emblazoned with gang tattoos on his neck. I'm not saying that gang members can't grow up to be doctors, but most medical advertisers would not favor as their spokesperson a tattooed person too young to have completed the long educational process to become a surgeon! And, since more than fifty percent of medical school enrollees are currently women, not all doctors in your images should be men, either. Equally irritating to the image buyer is the dominance of photos of a business team being led by a graying older man in a three-piece suit. Today's successful entrepreneurs are often under thirty, and many women are at the helm of large companies.

Another important demographic to cover is the gay and lesbian community. If you use models to represent gay couples or individuals, you should add a phrase to your model release that indicates you have permission to depict them as living a gay or lesbian lifestyle. This is to protect models who may want to maintain privacy about their lifestyle choices or who are merely acting. Gay and lesbian models should be used in family shoots with their children and in lifestyle images that show regular day-to-day life without an overtly sexual emphasis. Don't use the keywords "gay" or "lesbian" unless you have a model release that indicates permission to use that designation. I've seen photos of two men who are obviously brothers captioned as such ("two brothers") but keyworded as "gay": This is a misrepresentation you don't want to make.

Group shots are the most difficult to cast and produce (inevitably someone's eyes are closed or another person has a weird expression), but they also tend to be the most salable. The challenge for casting family groups is to locate people who appear related. Families are a mixed

This young Hispanic woman is attractive, and both her ethnicity and her fuller figure are valuable personal attributes to a photographer looking to show diversity in his portfolio.

Older models should look their age but exude a healthy, positive attitude.

bag these days, with blended and nonrelated individuals making up family groups, but buyers seem to prefer idealized, biologically related groups, so keep this in mind when casting family groups.

Using nonprofessional-looking models can add a dose of reality to your photos and make them more interesting to the target demographic.

▎ *PHOTOGRAPHING MODELS*

Meet with each model in the days before the shoot for a short conversation. Go over your ideas for the shoot and the part you want the model to play. Discuss makeup and wardrobe if the model is going to provide his or her own. Take a few test shots; you'll know immediately whether the person freezes in front of the lens. You can also use a print from the test shots as partial payment for the job and promise delivery on the day of the shoot. Use this meeting to go over what it means to be in a stock photo: specifically that you will have little to no control over how the photos are used beyond the prohibition against improper use (in pornography or unlawfully). Firm up the final fees you expect to pay, and ask the model to read and sign the release.

Ideally, productions that include models should have a wardrobe stylist included in the budget to oversee the look of the clothes and props. But owing to cost restrictions, that rarely happens for self-produced stock photo shoots. Lorena Arnold, founder of Hola Images in Miami, came up with a novel workaround solution to needing expensive stylists when she first started her business and money was tight. She visited a store that catered to the type of model she was featuring and leveraged the store's knowledge of current trends by using the wardrobe featured on the mannequins in its displays. She purchased the items with the understanding that they were returnable. To transfer the looks seamlessly, she had a salesperson put all the clothes and accessories from each outfit on individual hangers. Once at the shoot, she handed the hangers to the appropriate models for complete wardrobe changes. After the shoot, she arranged to return the clothing, making sure that every piece was accounted for and in perfect condition. The resulting looks were up-to-date, color coordinated, and fashionable. Another option is to use a model's own wardrobe, because sometimes models have a stronger personal style and look that is more current than you could create.

A note of caution: Although select stores that don't have a return policy will allow you to borrow clothes and accessories for a small fee if

they are returned clean and undamaged, in certain areas where a lot of photo shoots take place, some stores have computer programs that track returns. Thus, if an individual has made a habit of returning clothes, the store may stop accepting them. There is no way around this, short of discovering which stores have this policy and avoiding them.

In your first meeting with the model, describe what attire you would like her/him to bring in terms of style (casual, formal, business), colors, and variety. Don't neglect shoes to go with each outfit. Most importantly, have an iron and ironing board available on the day of the shoot. Cover the same topics if you are using a professional stylist. Hiring skilled pros in this field can cost more than four figures per day, and for that fee you should get the entire wardrobe you need complete with a variety of accessories. If the stylist or anyone assisting you intends to buy clothes for the shoot, make certain they can be returned and, if not, require that the stylist return all the clothes to you after the shoot; you can use them again or donate them for a tax deduction. Price tags should be kept on the clothes for possible return, so during production, keep your eyes open for any visible tags, a clear no-no. I've caught price tags peeking out of clothing on several shoots when the photographer was busy shooting and the stylist was occupied getting the next model ready.

Quick Tip:
I prefer portraits that show the subject looking straight ahead, connecting with the camera, so the model appears to be speaking to the viewer. However, many buyers have tired of portraits showing direct eye contact and are increasingly making requests for images with the models in profile or looking off-camera.

©JACE TAN/SHUTTERSTOCK

Spend time with a model before you start shooting, and do a test shoot a few days in advance of the booking. The model will be more relaxed, and you'll get some ideas about how to engage him or her on set during the actual shoot.

©ZSOLT NYULASZI/SHUTTERSTOCK

©YURI ARCURS/SHUTTERSTOCK

Portraits that show the model looking off to the side can be selected as spokesperson photos. This image is especially effective because it leaves negative space to the right for a product photo.

An assembly this large is very expensive to shoot because of the diversity of professions and workers, but it could also be very profitable. These models were photographed one by one, and then the photos were combined into a composite.

Unless you relish spending hours slaving over each image with Photoshop, keep all logos, trademarks, and brand names out of the picture. Very busy fabric patterns are distracting, so choose solid-colored clothing for most wardrobe items. Another good idea is to expand the wardrobe to cover several seasons, even for a half-day session. I recall a series of images taken in a classroom with a single student standing at the front of the class wearing sleeveless summer clothes. Adding a sweater to the wardrobe would have greatly expanded the usefulness of the photos and should have been a key clothing element, as many images featuring schoolchildren are tied to back-to-school articles and promotions in the fall.

Beware of overly styling your shots, which is a common misstep, especially for lifestyle photos. If your photos have a high-fashion look, the final images will resemble those in a department store catalog. Slick fashion images or models are rarely successful in the stock photo world because the images are too staged and the looks too artificial for multiple uses. That said, do remind prospective models to come to the shoot with manicured or at least cleaned and clipped nails. It's a monster challenge trying to hide unkempt hands in a photo or running out to get manicure supplies to fix a bad polish the day of the shoot.

©SILVADNYEV OLEKSANDR/DREAMSTIME.COM

As a prop, alcohol enhances the message in this photo. However, many advertisers require proof that a model is at least twenty-five years old in ads featuring alcohol. It's smart to add a photocopy of a driver's license or passport to the model release to prove age, but you should block out all personal information and ID numbers when you copy the release for submission.

©VOLODYMYR KUDRYAVTSEV/SHUTTERSTOCK

Traditional stock photo companies are conservative when it comes to artistic creativity in order to ensure that their images will satisfy a broad range of users. Consequently, they sometimes pass over highly creative work such as this image by Volodymyr Kudryavtsev.

©VALUA VITALY/SHUTTERSTOCK

Makeup professionals can add an artistic touch, ensuring that flaws are covered and that the model's face reflects light in an intriguing way.

Makeup artists are expensive but well worth the money. If your budget doesn't allow you to hire a pro, you have several workable options. Many women are excellent at applying their own makeup. Another alternative is to hire makeup artists from the cosmetic counters at large department stores. I've found that many of these individuals have excellent training and would like to expand their experience by working on a photo shoot. I usually duck in, get the free makeup consult, and then chat up the person to see if he or she is interested in working on a photo shoot.

Even if you have interviewed a model during a test shoot, spend a little time with him or her on the day of the actual shoot. The more relaxed and comfortable the model feels, the better the photos will be. Have refreshments and lunch ready if the shoot takes all day. If you're not comfortable with casual banter or relating to new people, have someone else there to put the models at ease. Some models will want lots of direction; others will be prepared to give it. But don't let the model be the boss! And one last word: Remember to have the model sign the release *before* you begin shooting.

©NIDERLANDER/SHUTTERSTOCK

©NIDERLANDER/SHUTTERSTOCK

©NIDERLANDER/SHUTTERSTOCK

Makeup has to be appropriate for the role the model is playing. An evening or glamour shot will require much heavier makeup than an office shoot or health spa series. These three images are all of the same model.

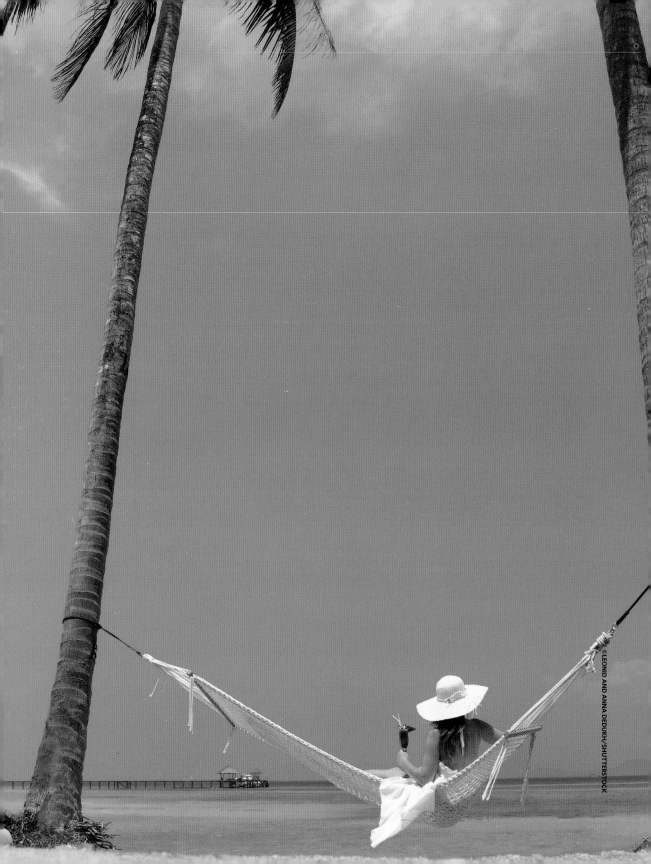

Decades ago, every advertising photographer either had or wanted his or her own studio. It had to be complete with a fully equipped kitchen, models' rooms, wardrobe, prop closets, a full array of lights, racks of seamless (large rolls of paper available in a variety of colors that studio photographers use as backdrops), cameras, stands, lenses, and miscellaneous gadgets overseen by a studio manager. Once their overhead grew, however, studio owners realized that renting out their spaces and even equipment was a stand-alone business and developed fully equipped, day-rental studios as business ventures. The RM or RF stock productions that are fully funded by production companies take ample advantage of these studios. For more economical shoots, however, most microstock photographers set up temporary shooting areas in living rooms and garages, or they shoot exteriors—all to their financial advantage.

©RECHITAN SORIN/DREAMSTIME.COM

This wild fox was photographed about 180 miles from the photographer's home. The Internet provides photographers with access to marketplaces far afield from their home base and allows users to download images of native animals without the tremendous expense of sending a photo crew to remote locations.

To a very limited extent, photographers and full crews are still sent to far-flung locations for expensive, weeklong shoots at $2,000/day rates with catered meals, rooms in the best hotels, and expensive wine for the wrap party. But as fees continue to fall at traditional licensing companies, these trips are being scaled back in favor of using stock images from photographers based at the destination. Consequently, talented amateurs and professionals from hundreds of countries around the world are able to license "exotic" destination images without ever leaving home.

Photographers on a budget have discovered that many popular stock locations can be re-created close to home by using easily accessible local exteriors. Of course you can't shoot a snowboarder on a lift from your apartment in Dallas, but you can get a kid to pose in front of a white seamless background in your living room or garage with the correct snow gear and some fake snow (try instant potato flakes) and take a cool portrait.

You can build relatively inexpensive sets within any space by hiring a carpenter or doing it yourself. I have been on shoots where the photographer created the illusion of a wood-paneled boardroom, a cube farm, a living room, and a classroom—all in the same space and all in a day's shoot. The sets were created in two dimensions. The boardroom consisted of a "wall" of wood panels mounted on a simple frame with braces at the bottom to keep them from falling over. The classroom consisted of a large movable blackboard against a wall as the background, with a few school desks in the foreground.

If you don't have space at home or are not able to absorb studio rental costs, use your connections with friends and colleagues who have offices or businesses. Where do your friends and family work? Are any of these locations available to you? Are they suitable? Remember that if you are going to light a situation, you will need a decent-sized space. Here are just a few possible spaces in which to photograph:

- New condo and housing projects have fully decorated model homes. Depending on the size of the project and your connections with either the developer or the company marketing the homes, you can arrange to trade photos for use of the space for a day.
- Make friends with a real estate agent. You may be able to gain access to furnished or staged homes and gardens offered for sale in exchange for prints or an offer to shoot a new listing.

- Doctors in private practice may allow you to shoot in their office or exam room after hours. This tactic works best if you are a patient or friend. Never shoot in a hospital, medical facility, or office without permission. Patients have a legal right to expect (and deserve) privacy while seeking medical care.

- Use local businesses and restaurants in exchange for images they can use on their websites.

- Companies that offer shared and furnished offices complete with reception and conference rooms will often rent their spaces for a daylong photo shoot.

- Advertise on Craigslist or similar places with an offer to pay a fee to use a private home and/or garden. Be very specific about what you want and are willing to pay. Ask to see photos from several angles before you go further.

- As a last resort, contact a location scout. These services have preselected sites of all types, from cottages to mansions. They can find business settings and steer you to outdoor settings you may not be aware of. The downside is that these services are expensive—as high as four figures per day, plus the location rental. If you are putting together shoots for microstock, you probably can't afford them and still make a decent return per image (RPI).

You should have insurance when you are shooting on private property in case you or someone with you causes damage. Shooting in public locations often requires permits, and failing to get the proper paperwork can get you arrested if you are in a secure location. Shipyards, airport cargo or security areas, bridges, ferries, and rail stations are all areas that could be subject to terrorism, so it's best to get all the proper permits ahead of time, or steer clear of them if photography is off-limits.

You may find art hanging on the walls of a private home or a rented business location, and if you include it in your photos they are likely to be refused by the microstock agencies, since it's assumed that the artwork is protected by copyright. Bring a few of your own framed prints to replace the ones that came with the location or simply edit out the artwork in the final frames.

Property releases (permission to use the image of someone's real estate) are not nearly as important as model releases. Even so, the more

The illusion of a large, formal dinner can be created by photographing a single place setting on the edge of any table covered with a white linen cloth. Frame the shot to catch only the single setting, silverware, and a vase of flowers. Use a shallow depth of field so that the background recedes; this is especially effective if there are a few people in the background rendered in soft focus.

signed paperwork you have on your side, the less likely you are to get the dreaded phone call saying that some irate owner is demanding payment because he saw a photo of his barn in an ad (see more on this on page 157).

Some building owners employ attorneys to send letters to photographers regarding the use of photos of famous places, such as the Chrysler Building, the Hollywood Sign, and the interior of the New York Stock Exchange. The owners maintain that these buildings are trademarked or copyrighted, a claim usually refuted by well-known trademark and copyright attorneys. Out of caution, many stock businesses will not accept images of these places because of the hassle and expense of dismissing disputes if they arise.

Photos that include certain objects may be turned down by a stock business because of what is known as "trade dress" (the instantly recognizable and trademarked shape of a product, such as that of the VW Bug). Examples of registered trade dress are given by attorney Nancy Wolff

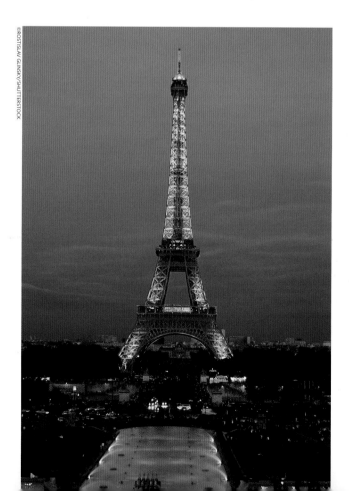

©ROSTISLAV GLINSKY/SHUTTERSTOCK

Photos of the Eiffel Tower at night may be used only in conjunction with editorial copy about the Eiffel Tower because the design of the lighting is protected. But don't be discouraged—this doesn't mean you should avoid taking photos of all private or public buildings, as most uses are usually okay.

in her book *The Professional Photographer's Legal Handbook* and include familiar items such as "the red LEVI tab affixed to the vertical seam of the back pocket of jeans; the shape of LIFESAVERS candy and its hole; the three stripes on ADIDAS athletic shoes; the FERRARI DAYTONA SPYDER classic sports car; Black & Decker Snake Light flashlight; and the Rubik's cube puzzle." Some companies refuse photos of Mac keyboards because of the Apple logo on the control key. Others refuse photos of Times Square or city skylines because of billboards or company logos on buildings or stadiums. It's best to avoid these problems by using more generic views of props and city skylines. For example, instead of using identifiable Olympic medals with the rings logo or an Oscar award, use nonidentifiable medals and blank trophies or statuettes as props instead to evoke the concept of "winner."

Thanks to Robert Kirschenbaum, owner of the Pacific Press Service Photo Agency in Tokyo, I had the privilege years ago of spending a morning in Paris at the apartment of Henri Cartier-Bresson. During that period in his life, he was spending time drawing rather than on the street photography for which he was so famous. He mused, "Today it feels like a photographer has to have a lawyer attached to his Leica in order to work." It does indeed.

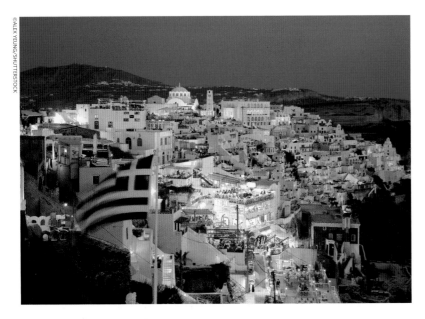

©ALEX YEUNG/SHUTTERSTOCK

The flag in the foreground lets the viewer know exactly which country is shown in the photo.

KEYWORDING
THE KEY TO SUCCESS

Mastering the art of keywording is as important as mastering the skills needed to take a best-selling stock photograph. Why? Because no matter how stunning, clever, or skillfully composed an image may be, one that has been poorly identified with inappropriate keywords will not be found and thus will not achieve its maximum potential. Search engines on all stock sites depend on language to narrow the field to a related set of images in order to match a request. A photo may be worth a thousand words, but without at least a few good identifying ones, it might as well not exist.

There are two schools of thought on the appropriate number of keywords: According to one, every possible item in an image should be identified, no matter how incidental, while others (including myself), think that, to maximize the user experience, only very relevant words should be used. I find it difficult to justify more than twenty keywords for some photos, while others can easily find sixty or more

for the same photo. I have spent my career working toward making the most appropriate images available to users, while some photographers want their images to show up in searches even if they are not remotely relevant. They support their argument for using maximum keywords, no matter how dubious the connection to the image, because sometimes it results in downloads even from irrelevant keyword searches—which means money for the photographer. At the other extreme, some photographers commit sins of omission. Imagine a photo of a man standing at a door holding a bouquet of flowers behind his back. The minimalist would enter "man," "door," and "flowers" and call it quits, overlooking countless other possibilities that suggest the concept of romance.

No one wants to wade through countless useless image results when their needs are specific, and often time-sensitive. I used microstock photos for several years while writing a weekly blog for Dreamstime.com, as well as doing photo research for this book. I'm usually working toward a deadline, and my time is precious. While searching for "snow" one time I found a photo of a golf bag and a golfer on a putting green, with no fluffy white stuff in sight. This didn't add to my efficiency and was more than mildly irritating. A user searching for snow doesn't want a photo of a summertime activity. Don't use keywords that confuse or insult your potential customers. As a steady user, I have also learned to recognize photographers who keyword

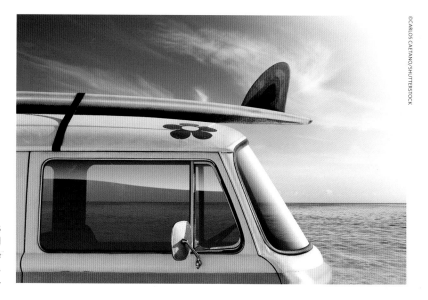

The conceptual keywords "summer" and "1960s" would be appropriate for this image of a vintage bus.

their location images accurately versus those who keyword them with the name of any place the photo *could* have been taken but was not. The resulting bias certainly affects my choice of downloads.

Dreamstime.com smartly offers its users the opportunity to flag incorrect keywords when inappropriate images pop up in a search. It gives the frustrated shopper a place to register complaints and provides staff with useful information. Unfortunately, it's not possible for any microstock site to police all keywords, owing to the huge volume of images that flow into these sites daily. "Spamming" is also a big keywording problem; it refers to the act of attaching popular search words, such as "sexy" and "business," to photos that aren't related. I've found "sexy" attached to a photo of a cell phone. All microstock companies have policies about this practice and will block photographers who persist in spamming.

Most microstock keywording is required in English. This can be problematic for non-English speakers, who will cut and paste keywords from similar images without knowing what the words mean. For example, such a user might paste the keywords for a photo of a woman sitting on a beach under a beach umbrella holding a cocktail to a photo of a deserted beach. Then a user searching for "umbrella" will be mystified when a photo of a deserted beach appears in the search results.

What are the most significant keywords to include? The thoughts that went through your mind when you decided to take the photo. If you decided to take a photo of a waterfall, obviously that will be an important noun in the list of possible keywords. Perhaps you are taking a photo specifically of Iguaçu Falls; since it's on the border between Argentina and Brazil, the location and name of these famous waterfalls are important. Next, you would want to add the physical elements in the image, such as "water," "spray," "river," and "mist," among descriptions.

Here are some keywording mistakes to avoid:

- Making assumptions about what *might* happen. A photo of a single glass of wine should not have the keywords "drunk" or "drinking." It's a picture of a glass of wine, not a drunken person; nor is there any drinking going on. Another example is to label a photo of a house "mortgage" or "foreclosure." Maybe the homeowner has a mortgage, but the photo shows nothing to support that.
- Using keywords based on things only you could know, which aren't

©MARC DIETRICH/SHUTTERSTOCK

This photo of a man on a scale should not have the keywords "fat" or "skinny," as he doesn't appear to be either. He may be fat and hoping to lose weight, or the alternative. Both are assumptions and should not be associated with the image.

@LISAFX/DREAMSTIME.COM

Misleading keywords can result in poor search results. This model was correctly identified as "middle-aged," but the keywords also identified him as a dentist, an orthodontist, and an executive. He may be a dentist, but a user searching for dentists would be disappointed with this image. The keywords also included "advertisement." The photographer was citing a possible use (advertisement for a dentist) as a keyword, which is not recommended by microstock sites.

apparent to the viewer. The person in your photo may be a tourist, for example, but all the viewer sees is a shot of a person leaning against a nondescript wall. "Tourist" is not appropriate as there is nothing in the image to indicate that the individual is one. Don't label images with what you were doing when you took the photo. For example, when searching for "hike," I found a photo of a moose; I suppose the photographer was on a hike when he took the photo. On that same search I found a photo of a compass. A compass might be useful on a hike, but the close-up of the compass is not a photo of a hike.

- Ethnicity mistakes. Be accurate in your designation of a person's ethnicity.
- Geographic mistakes. It's acceptable to label a photo of a beach in the Bahamas with "Caribbean," but it's not okay to also list all the islands in the Caribbean where the beach might be located. If a person is looking for an image of a Puerto Rican beach for a travel site and a search on "Puerto Rico" returns a beach in the Bahamas, problems could occur.
- Using opposites. Examples include wet for dry, or sad for a photo of a laughing child.
- Using the model's or pet's name in the photo caption or keywords.
- Forgetting about the user. Ask yourself why a buyer would want to download an image. Keyword as if you were that buyer. Also, ask yourself, "What does the photo say?"
- Age mistakes. See the sidebar opposite.

Microstock sites have enhanced the search experience by adding subject categories in addition to keywords. Users can search within categories or, on a site such as Shutterstock, limit keyword searches to particular categories. Each site has slightly different category designations and rules. Most are self-evident, although the process adds to the time-consuming aspect of submitting one's work directly to multiple sites.

Here are some loose guidelines for keywording age:
- **Infant/baby:** A child from birth until he or she begins to walk. Other suitable words are "newborn," "toddler," "preschooler," and "child." If the gender is obvious, include "boy" and "girl."
- **Child:** Children from infancy to age twelve. Specific keywords, such

as "kid," "grade-schooler," "middle-schooler," "tween" (nine- to thirteen-year-olds) are usually confined to children ages five to twelve.

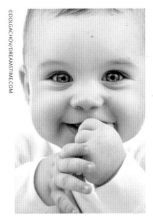

- **Teen:** Models aged thirteen to nineteen. For this category, be certain to get "teen" or the actual age into the image data in either the caption or the keywords. Other descriptive words are "youth," "adolescent," "teenage," "teenager," "teenaged," "boy," and "girl."

- **Young adult:** Multiple words are tricky. Using "young adult" will return images of models from birth to the mid-thirties because of the word "young," unless the site allows for age-specific searches (such as on Dreamstime). If you don't know the exact age, base the keywords on how young or old the model appears. Use "young adult," "man," or "woman," and add the profession or trade if it's obvious ("businesswoman," "fireman," "teacher") and/or the relationship ("mother," "father," etc.). Although a common term for a pretty woman under the age of forty is "girl," as in "girl poses in bathing suit," this keyword should apply only to children.

This image should have the keywords "baby," "child," and "infant," in addition to others such as "smile" or "happy."

- **Middle-aged:** Reserved for people between thirty-five and sixty.

- **Retired:** People over age sixty-five. The designation should apply only to healthy and active adults. Other good keywords: "mature," "senior," "boomer," and "older" (as in "older adult" or "older man").

- **Elderly or Old:** The very old—depending on their looks, from seventy on up. They may be retired, but generally that word is reserved for active people.

■ Keywording *for* Age

When keywording for age, the most specific restrictions are for children and young adults. A sixteen-year-old might look eighteen, but if he isn't, you need his guardian to sign a minor's release. (In some places, he has to be twenty-one to qualify as an adult.) Also, if you shoot nudes, make sure that the ages on the release and in the keywords describe an adult. The keywords "child" and "sexy" should never appear on the same image. Images of minors are limited to certain uses. In the United States, most advertisers will use only photos of people over twenty-five in ads for alcohol. In general, it is better to be more specific about age than to apply a wide range, especially with children.

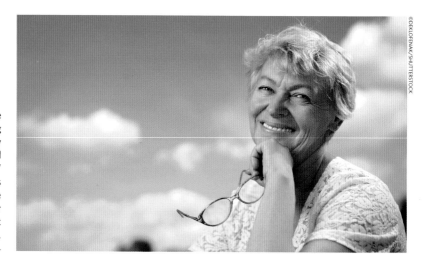

©DEKLOFENAK/SHUTTERSTOCK

The statement that age is relative is ever so true when keywording stock photos. This apparently healthy and happy woman could be deemed a "senior" or "retired" but not "elderly" in most people's understanding of that word. On the other hand, if she were frowning or appeared to be ill, "elderly" might be an appropriate keyword.

PHOTOEUPHORIA/DREAMSTIME.COM

This ten-year-old is both a "child" and a "tween."

◼ KEYWORDING TOOLS

According to Lee Torrens of the blog Microstock Diaries, the keywording facility at picNiche.com allows contributors to find which keywords are (potentially) the most lucrative. Lee explains: "By analyzing the supply and sales quantity of images in the microstock market, picNiche returns an index calculated on the supply and demand of a keyword. The higher the index, the greater is the opportunity to sell photos with that keyword or combination of keywords. The tool also makes suggestions of similar terms with high indexes based on previous searches."

Another tool that helps contributors select keywords is found at http://arcurs.com/keywording. By entering the first few keywords, you will be presented with matching photos that already exist at various microstock agencies. From these results you can indicate which images are similar in content to your own, and the system then presents you with the list of keywords common to the images you've indicated. This tool can help you gain quick access to a list of appropriate keywords, although it's crucial that you go through the list and remove any that are not relevant. Irrelevant keywords can cause your images to be rejected or, if accepted, can harm your earnings by adversely affecting the search algorithm metrics of your account.

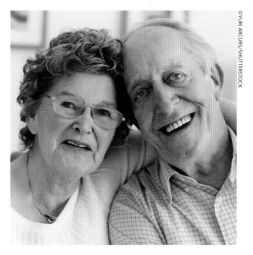

This young woman could be an "older teen" or a "young adult." Because some uses require that the model be over eighteen, twenty-one, or twenty-five, it's smart to indicate the true age of the model in the image's metadata.

Age designation guidelines need not be followed to the letter. This couple is elderly but healthy and active enough to be called up in a search for "retired."

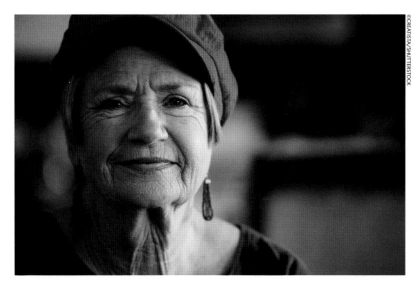

This woman is clearly elderly, yet unlike many photos of people her age, she doesn't appear depressed or ill. Since people are living longer and in better health these days, there is increasing demand for photos of healthy seniors late in life.

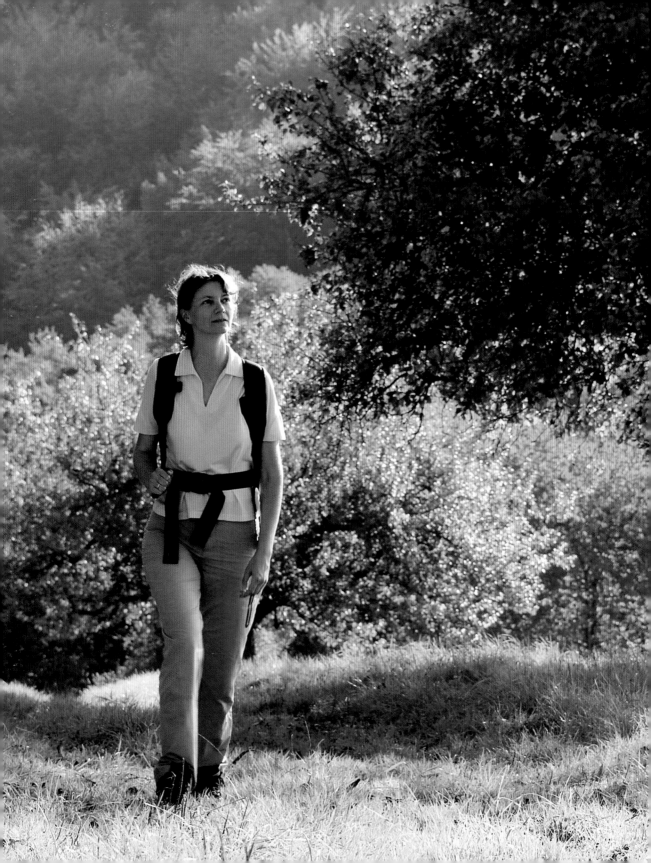

CASE STUDY
A DAY HIKE WITH MODELS

It can be intimidating to consider all the various scheduling and planning tasks that a successful photo shoot requires. The case study in this chapter will walk you through the steps involved in developing a hypothetical photo shoot. You can use it as an example of how to plan and complete a self-imposed assignment using models and an exterior location for a range of subjects. It may include steps that your shoot will not require, but hopefully you will also see some pointers that will make your next photo production shoot go more smoothly and the resulting images more successful.

STEP 1: DEVELOP AN IDEA

Your first step is to develop an idea for the shoot. I selected a hike because it offers many possible scenarios. Hiking is a universal activity that is used in ads and specialty magazines. It does not require much equipment to gather for props, but at the same time, it is an activity many manufacturers and retailers look for on stock photo sites. Hiking photos provide images that serve as metaphors for healthy living, adventure, and travel.

To develop your idea, spend some time doing online research. This can be a tedious task when your shutter finger is itchy to get going, but stick it out and the final shoot will go more smoothly and produce a wider variety of usable images. Research begins with a simple word search on Google or another search engine. Entering "hiking" leads to the website of the American Hiking Association, where there are photos of two women hikers. One wears a baseball cap and the other has her hair tied back with a scarf. The models are carrying water bottles and binoculars; both are wearing sunglasses and appear to be in their late twenties. An image such as this offers ideas for models, wardrobe, and a prop list.

Visit retail establishments catering to hikers to learn the names of companies and manufacturers that supply hikers with equipment and clothing. Then research their sites online. Look at books about hiking in your region. Engage the store clerks in conversation about hiking; perhaps they can suggest good locations or know hikers who might be willing to model.

Galyna Andrushko has provided a series of images of the same hike that could be grouped in a sequence in a brochure or online, making them very marketable.

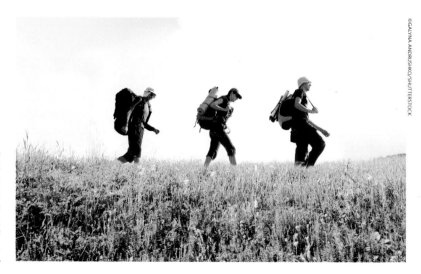

©GALYNA ANDRUSHKO/SHUTTERSTOCK

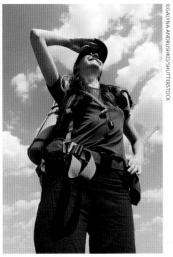

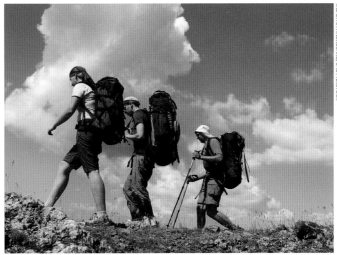

This model isn't overburdened with trademarked gear, making the shot ideal as a "spokesperson" image.

Andrushko has built a brand with her hiking photos. She has used different models in settings ranging from meadows to high mountains, in both summer and winter.

Check the microstock and traditional stock photo company sites for the most popular hiking images. Are there ideas you can use? How can you improve on the existing images? Can you see what is missing from the least popular images, and what to be certain *not* to do? Search for "hikers" on Flickr. Do any of them suggest appropriate props you might include, such as walking sticks?

STEP 2: SET A BUDGET

A budget begins with what you are willing to gamble on a shoot. For this production, for example, you could keep things very basic, spending roughly $20 for food and wine (the wine is a prop, so it doesn't have to be drinkable), $15 for parking, whatever gas you need, the models' fees, and the cost of props and wardrobe; you may end up spending a few hundred or a few thousand dollars total. Or you could easily spend $15,000 to use professional models, hair and makeup stylists, assistants, rental equipment, travel expenses for cast and crew to a faraway location. . . . Oops, now we are getting beyond the $15,000 mark!

Some RM and RF stock photographers used to spend an average of

©KURHAN/SHUTTERSTOCK

Shooting a hike in a local park allows you to easily add a variety of activities. For example, a bicycle could be brought along to turn the hiking scenario into a bike ride for a few shots.

$25 to $75 per edited shot. For microstock images, however, the average shouldn't be more than $7 per accepted image, and less if possible. (You should be pleased if ten percent of the images from any shoot get accepted after the duds are tossed.) Know your average acceptance rate and return per image, and use those figures to estimate the number of final selects to help you arrive at a budget. Once you have achieved some success in microstock, set aside some earnings to upgrade your equipment and invest in more expensive productions now and then.

If this is your first shoot, it's best to do a budget very early in the process to make sure you don't get too far along before realizing you're spending too much money. Once you get a few productions under your belt, you'll start to get an intuitive understanding of what your general costs will be, and you can define your budget later in the process, after you have the shoot storyboarded.

STEP 3: SCOUT LOCATIONS

You should pick a nearby location to save time for shooting rather than spending it driving to the spot. Check with the local chamber of commerce or tourist bureau for suggestions. If you live in a heavily urban area, consider using a park to simulate your fantasy hike. Once you have established a general location, visit the area to nail down exactly where you plan to shoot. Is there a picnic area with places to build a fire? If so, you'll want

to be there when the light is right to best show off a campfire. Look at the available light during the course of your scouting hike. What equipment will you need to pack? During your scouting day, rapidly shoot images to use in mapping out a storyboard. Make a Web gallery of scouting photos to that end; as you review these images, more ideas will come to mind.

STEP 4: CAST YOUR MODELS

Your Internet research will have indicated what age models are most popular on the manufacturers' sites. For my hiking idea, I found three main demographics: a group of young models of the same general age, a family group, and a retired couple. A family with young-looking parents and teenagers might provide the most options, as the family hiking together could be one group while the parents and the teens could also be shot separately as couples. Each individual could be photographed as a solitary hiker as well.

Do you have friends or relatives who fit the demographics? Or will you hire models? This choice speaks directly to what you expect to make from the images by anticipating your average return per image (see page 32) and then figuring your budget (see Step 2 on page 147). See Chapter 8 for more about working with models.

A resourceful photographer could shoot this image without leaving town. The important elements are the props, which imply that the models are on a long hike.

Two major demographics for hiking are young adults and retired couples.

STEP 5: CREATE A WARDROBE AND PROP LIST

Your choice of wardrobe might be limited to what your models bring to the shoot; suggest clothing based on your Internet research and, in this case, a trip to the sporting-goods store. Another idea is to include several layers of clothing to allow for wardrobe changes. (If you keep the models in the same clothes all day, you will have too many similar images.) Props will depend on what you have available and what you are willing to borrow or purchase. For maximum flexibility, you might want to have both daypacks and camping backpacks with overnight gear. If you aren't hiking too far, include a small tent. Make a final list of desirable props gathered during your research, whether or not you think you'll have them available. Return to this list after you map out the shots to make certain you have all the necessary props covered.

STEP 6: OBTAIN ANY LEGAL FORMS OR PERMITS

Do research to find out whether your location requires any special permits. If a park employee or forest ranger comes along, will he or she ask you to show paperwork you obtained prior to the production? Can you legally build a fire? Contact the authorities in the park ahead of time. For more about legal forms and permits, see Chapter 12.

©JIRI SLAMA/SHUTTERSTOCK

Most sporting goods and clothing are heavily labeled with logos and trademarks. I am surprised this image slipped through with the blue logo intact on the woman's shorts.

MONKEY BUSINESS IMAGES/SHUTTERSTOCK

Photographing a single person from out of the group of models creates a sense of solitude.

STEP 7: ARRANGE LOGISTICAL DETAILS

Check with your models. Remind them to leave the sweatshirt with the team or university logo at home. Do they have hiking boots without logos? If not, can you tape over them so neither the tape nor the logo will show? (Otherwise you'll have to edit out the logo in postproduction.) Give the models your wardrobe and prop list so they will dress appropriately. Show them the photos you took on your scouting trip to help them get into the roles they will be playing.

Other important details to remember are:
- Who's driving? Does someone have an old Volkswagen bus or other retro car to add a nostalgic look to the shoot, or an SUV for a family hike? Can you use the car in some of the shots?
- Do you have the model releases? Even if the male model is your best friend and the woman is your wife, have them sign model releases or the microstock reviewers will reject the submissions. If you are in any of the images, you too will need to sign a release. Pack extra releases in case you come across willing models on the trail. New York City professional photographer Shannon Fagan emails or faxes his releases to the models in advance so they have time to read the

terms. Have the releases signed *before* you begin shooting, and have a witness sign at the same time. Remember: You can't be the witness to your own shoots.

- What will everyone eat and drink during the shoot? You have to eat on a daylong hike, so work a picnic into the production. Slip a tablecloth into one of the backpacks. If you can build a fire and cook hot dogs, all the better. Make sure there is plenty of water for everyone to drink throughout the day.

- Is your gear organized? You probably have a special place to keep your key pieces of equipment, but just to be safe, make a list and tape it inside your bag or camera case so you can double-check before you leave for the shoot and after wrapping up to ensure you haven't left anything behind. (Every day, somewhere in the world, a professional photographer forgets a key piece of equipment needed for a location shoot. Don't be that person!)

STEP 8: CREATE A SHOT LIST

Let your idea unfold, and refer to your research as you build your shot list. Here is one possible shot list for our hiking session:

STARTING OUT

- Packing the car
- Loading a backpack
- Looking at a map
- Driving away waving

ARRIVAL

- Getting the gear out of the car
- Putting on the backpacks
- Starting out on the trail

THE HIKE

- Solitary hiker looking over the lake
- Peering through binoculars
- Drinking water
- One climber pulling another up a slope, laughing
- Getting lost
- Having lunch/picnic
- Putting on suntan lotion
- Group resting, with feet dangling in a stream or lake

- Looking out or down as a group
- Solitary hiker coming out of the woods
- Collecting wood for a fire
- Building a fire
- Sitting around a fire
- Sore feet
- Cooking marshmallows/hot dogs

While it's important to plan your list carefully, keep in mind that the best shots can be unplanned, so leave room in your schedule for serendipitous happenings.

STEP 9: BUILD A STORYBOARD

Storyboard is a fancy name for sketches that are arranged in sequence. The term was first used to describe plans for films and animations. You don't have to do elaborate drawings; simply sketch each location and what you want to shoot. As you go, you'll discover what you need to do to capture the various shots, such as getting ahead of the hikers as well as shooting them from behind. This will assist you in scheduling the day so you arrive at the correct places at the right times. As you build your storyboard, double-check which props you will need for each shot.

STEP 10: COMPLETE FINAL PREPRODUCTION

A week before the shoot, confirm all the final details:
- Email the models a map and directions to the gathering area, and a time to show up.
- Confirm that they will be there and check again the night before.
- Gather your props and run a check on all your gear.

Of course, you could skip the entire preproduction/planning step and simply pack your camera, get a couple of friends together, and take snaps while you have fun. That could work too!

Galyna Andrushko completes her productions by shooting from every angle, including long shots that take in an entire vista. Here the model is dwarfed by the scene, adding a sense of drama.

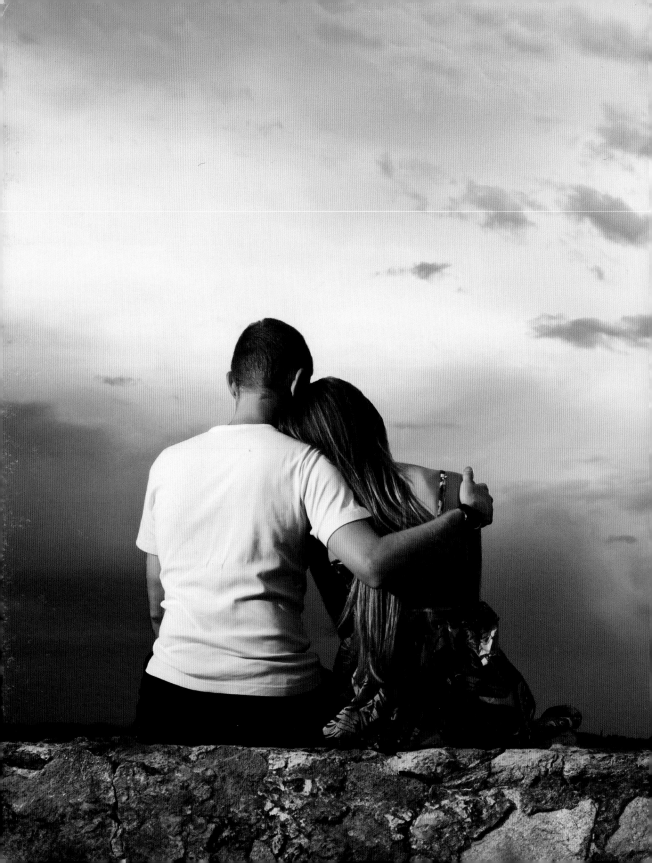

12

LEGALESE
FORMS, RELEASES, AND OTHER FINE PRINT

Although I am not an attorney, I have been an expert witness in state and federal courts in matters of copyright and photo licensing and am qualified to give appraisals about the future value of licenses. As such, the information in this chapter is based on my years of business experience. However, should any of the information here apply to you, please consult with an attorney for clarification and confirmation.

▌ MODEL AND PROPERTY RELEASES

People often ask me, "Do I need a model release for this image?" The answer has to be, "I don't know" because it's not the photo that requires a release but the *use* of the photo that creates the need for a model or property release. Let's assume, for example, that you have taken a photo of man standing at the scene of a fire. You can freely upload this image to any number of citizen journalism or other social-networking sites as a news item without including a model release. If the fire is newsworthy, you might license your photos to a local newspaper/media outlet or a national publication. Do you need a release? Probably not, so long as the image is used in conjunction with an article about that fire.

Now let's say a publication uses your fire photo in an article about arson, cropping the photo to clearly show the man's face. The caption implies that he is an arsonist. If the photo is published with a caption that says the man may have set it, both you and the publisher might as well call your lawyers to get a head start defending yourselves from the lawsuit, as you have publically accused the man of committing a felony.

Finally, imagine that the man's image appears in an ad for fire insurance. In this case, a release is required. Model releases are required from any individual who is recognizable in an image used for advertising or promotion.

Is it your legal obligation to provide the release or to warn someone that one is needed? Not really; it is "user beware." But if you want your images uploaded to most non-news stock companies, you should obtain model releases for images that show recognizable people. Some editorial users require releases as well. For example, textbooks sometimes require releases for images of children, and a magazine may want a release for a photo of a person used on its cover or as part of an article on a sensitive subject.

A husband can't sign a release for his wife, nor can a brother for his sister. A legal guardian must sign a minor's release for children under the age of consent, even if they are the photographer's children. The age of adulthood varies from state to state and country to country; be aware of the requirements where you are shooting. If you are taking photos of unaccompanied models who appear to be in their late teens through early twenties, photocopy their driver's licenses or passports so you have proof they are adults. If they are not of age, dismiss them unless you can obtain a minor's release before you begin. Some companies require that a copy of

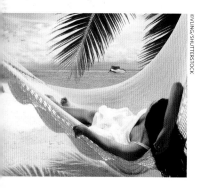

©YLING/SHUTTERSTOCK

Some companies refuse any nonmodel-released images that contain people, whether or not the model is recognizable. Is the person in this photo recognizable? Some might say yes, others no. To be safe, I would recommend a release, only because the model could recognize herself and perhaps cause problems.

the model's ID accompany all model releases. Increasingly, stock companies are requiring that model releases be witnessed by a third party.

Never start shooting before getting the model and/or property releases signed. I have had photographers report back that once the shoot was finished, the model decided not to sign. In one case, there were four models used, and the guy who wouldn't sign was in all the photos. The entire day's work was lost.

It is much easier to obtain releases while traveling abroad if you have one in the native language of the country you're visiting. Most microstock distributors make model releases available in different languages. Other companies will accept releases only in English. Unless you have the heart and soul of a salesperson, you might find it intimidating to approach strangers in a strange land, even with a release in the local language. How do you approach this problem? Speak to the concierge at your hotel or use your network of friends to arrange a reliable contact at your destination. What about releases for pets? After all, animals are people too. Attorney Nancy Wolff clarifies: "The answer is, almost never . . . the exception would be if the animal were a recognized character, such as a movie or TV character. Then there might be a trademark claim."

I advise discussing all issues relating to model and property releases with an attorney. For example, some property owners try vigorously to protect images of their buildings by threatening photographers and publishers with lawsuits. Most legal advisers agree that they don't have a leg to stand on, but the hassle of responding to threatening letters has motivated the Picture Archive Council of America (PACA) to provide a list of properties that have caused problems in the past.

In addition to trademarks and logos, one needs to obscure auto license plate numbers as well as identifying numbers on boats and private airplanes. Even the color combinations on some medicines are recognizable as belonging to a brand-name drug, so it is best to mix and match two parts of over-the-counter capsules to avoid having a medicine recognized.

▨ MICROSTOCK AGREEMENTS WITH PHOTOGRAPHERS

It's your responsibility to read the agreements that govern your relationship with a microstock agency or any other service or site that accepts your work.

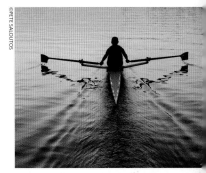

In this shot, nothing is identifiable, not even the location, making it legally airtight.

Always ensure you have a minor's release signed by a legal guardian when taking photographs of children.

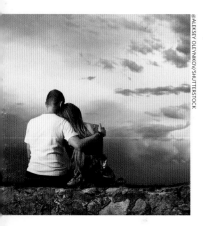

There are many photos of couples facing away from the camera. An idea can't be copyrighted; it is the execution of the idea that is protected.

Here are a few common terms to become familiar with:

- **Exclusivity.** Microstock agencies want to build their brand and attract loyal followers by offering a wealth of exclusive images. Some photographers opt for exclusive rights with one distributor in order to gain a higher royalty, but many photographers believe that exclusives benefit the company more than the photographer, who loses out by limiting distribution of his or her images.

 If you sign an exclusive agreement with a microstock company, it's important to note that *all* your images fall under its terms. Thus, you could not submit any other images of any kind to another microstock company. This is different from traditional stock distributors, which are usually "image exclusive," meaning that the photograph and its similars are exclusive but the photographer is free to submit other images elsewhere. Although there are millions of microstock images available and zillions, it seems, on Flickr, violated exclusives do come to the attention of the stock companies. When they do, the photographer will be banned.

 Another quick way out the door of the microstock world is to download images from one site and upload them to another as your own. You are stealing. You will get caught.

- **Model releases.** You have the obligation to keep originals of all model releases in an orderly fashion so you can easily and quickly retrieve them on request. Faked model releases can and probably will get you into a world of trouble. And, if the site has a section for adults only, ensure that the models you submit for this category are legal adults.

- **Copyright.** Don't be a copycat. Don't violate copyright. Understand the obligations and rules of whichever company is licensing your images. Don't be surprised if the company takes an action that you do not approve of and/or were unaware of. It's your fault if you haven't read and understood both your own and the company's obligations.